Waltraud Nawratil

Abstract Nature

Painting the natural world
with acrylics, watercolour and mixed media

Search Press

CONTENTS

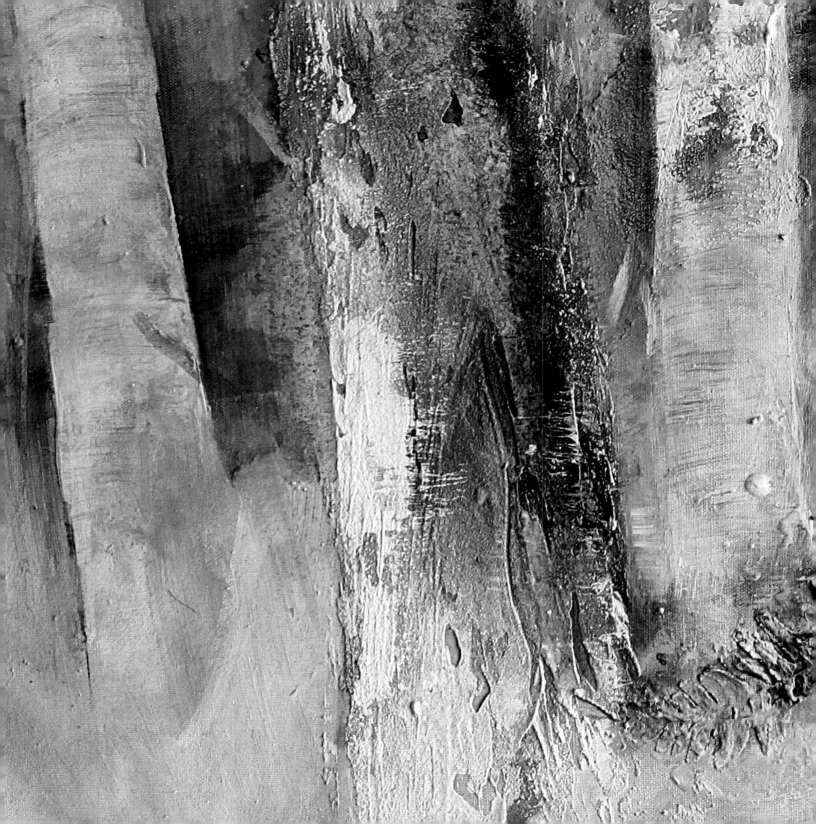

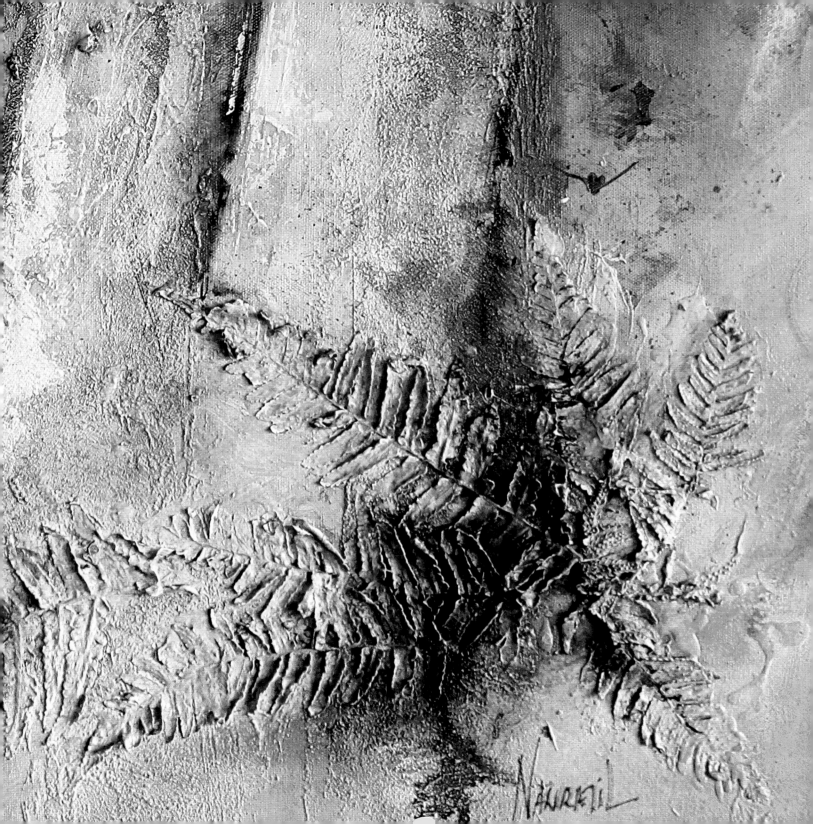

Introduction

A few months after I first started painting, my daughter, who was then aged 12, said, 'Mummy – looking at your pictures makes me feel really happy!'
I immediately realised that these were the pictures I wanted to paint: pictures that radiate happiness and are able to transmit this happiness to the observer.

Because of my deep commitment to nature, I paint mainly flowers and trees. However, to me this does not mean just slavish imitation of my surroundings. It means expressing my emotions, what I feel when I observe flowers and trees. I want my pictures to capture the colourful delight of nature and its life, its transformations, but also its vulnerability.

It was watercolour painting that first captured me, then the desire to combine the softness of watercolour with the strength and dynamism of acrylic painting. I try to capture the near-endless variety of colours in nature without making my pictures too bright, which would reduce their tranquillity.

Nature is both a patient model for me and a constant source of inspiration. I'm sure you will feel the same if you open your eyes to the seasonal changes in plants. Let yourself be inspired by the constant variations in flowers and trees over the course of a year, and use your pictures as a permanent testimony to these fleeting snapshots that will never fail to bring you joy and pleasure.

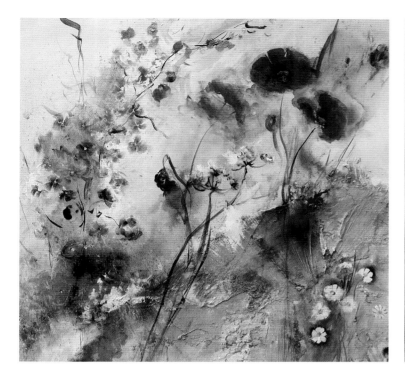

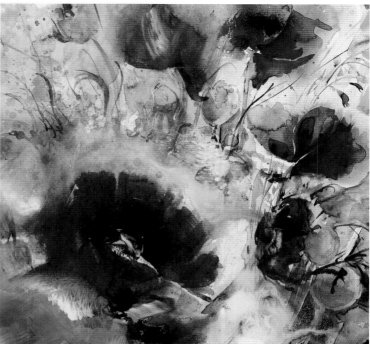

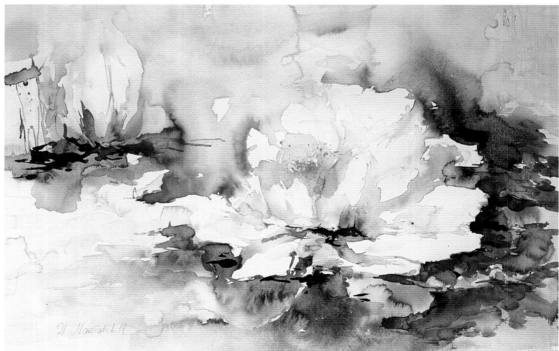

Top left: *Garden of Flowers*,
acrylic, 80 x 80cm
(31½ x 31½in)

Top right: *Poppies*,
mixed media, 50 x 60cm
(19¾ x 23½in)

Bottom: *Water Lily*,
watercolour, 50 x 60cm
(19¾ x 23½in)

MATERIALS AND TOOLS

In this chapter, I tell you about the materials that I use, which you will also need for the practical section later in the book. You will probably already be familiar with some of them, although others are more unusual. I like to work with mixed media in my pictures, and I use various natural materials on my canvases.

Your painting surface

The easiest option for a painting surface is to use canvas that has already been stretched and mounted on a stretcher frame; frames are available in lots of sizes and strengths. Remember that when painting small pictures, the stretcher frame may well be less than 2cm (¾in) thick. With larger pictures of about 60 x 80cm (23½ x 31½in) or more, I suggest that you use a stretcher frame that is at least 2cm (¾in) thick. Make sure the stretcher frame is thick enough as this will affect the stability of the frame. If a stretcher frame is too thin, the wood may well distort even if only slightly moist. You can also use watercolour paper, but if you want to display your finished picture later on, you will need a separate frame. For larger pictures of 40 x 50cm (15¾ x 19¾in) or more, the watercolour paper should be at least 600gsm (300lb) thick, as otherwise it will bulge too much when you paint.

Watercolour paper

Covered stretcher frame

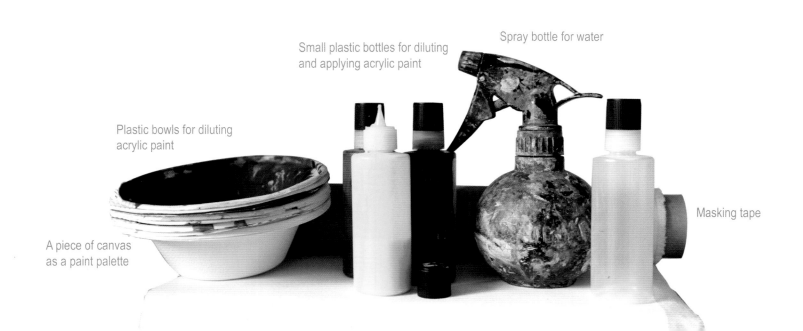

Small plastic bottles for diluting and applying acrylic paint

Spray bottle for water

Plastic bowls for diluting acrylic paint

A piece of canvas as a paint palette

Masking tape

Painting tools and accessories

There is almost no limit to the range of painting tools and accessories on the market. However, from experience I know that the utensils shown here are perfectly adequate. The exact sizes of the painting tools depend on the shape of your picture. I tell you my preferred format in the practical section, but of course you are free to use whatever you like. Please consider the brush sizes shown here as suggestions only, and try experimenting with different sizes.

Flat brushes in three sizes:
e.g. 60mm (2½in), 50mm (2in),
30mm (1in)

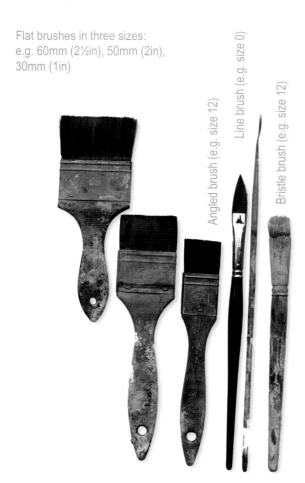

Angled brush (e.g. size 12)

Line brush (e.g. size 0)

Bristle brush (e.g. size 12)

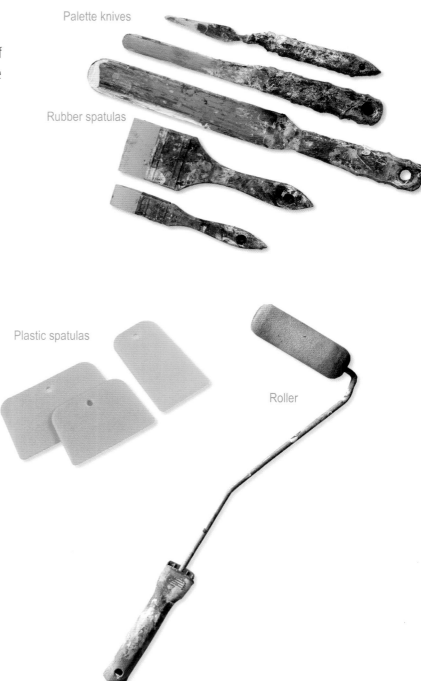

Palette knives

Rubber spatulas

Plastic spatulas

Roller

Paints

For the basic colours, I use paints by Daler-Rowney, and for special shades and airbrush paints I like to use Schmincke products. Aquacryl watercolours are only available from Lascaux. However, ultimately, the choice of colour and brand is up to you. You will find that, over time, you develop your own preferences.

Heavy body acrylic paints

Heavy body acrylic paints are particularly thick in consistency, and produce a clearly textured surface when applied using the spatula technique. These paints are ideal for collages.

Acrylic paints

Acrylic paints are available in different price ranges. I suggest you obtain your products from an art supplier. Cheaper products are usually inferior, and you will not achieve the colour quality that you would like for your picture.

Spray varnish

I use non-water-based black spray lacquer from a DIY store. When this kind of varnish is sprayed on a wet paint surface, it repels the paint rather than bonding with it. In other words, the varnish floats on the canvas, which creates pretty, free patterns.

Aquacryl watercolours

Aquacryl watercolours are based on a further development of the more traditional watercolour paints. They are made from a water-soluble acrylic resin and pure pigments. Their full colour intensity and distinct colour depth are amazing. As soon as you spray water onto the Aquacryl paint, the colour runs dynamically into the picture, and a very pretty glaze develops, which is guaranteed not to show any brush strokes. As Aquacryl paints are still water-soluble on canvas, you will need to set the finished picture. You can use normal, clear spray lacquer, although it is better to use a special acrylic spray varnish or ordinary varnish, also clear. That way you can be sure that the picture will not fade to yellow, even after decades. Take care not to work with too much moisture, both when overpainting with acrylic paints and when setting, so the colours do not mix unintentionally and so the Aquacryl paint does not dissolve.

Airbrush paints

Airbrush paints are brilliant colours based on acrylic that were developed for use with spray guns, but can also be applied by brush. If you spray a little water over the airbrush paints, they will run into the picture with a strong effect – like Aquacryl paints. You will not achieve results like this with any other painting method.

Additional materials

Fine or coarse paste

Ready-to-use products are available from art suppliers. You can combine sand, marble powder, acrylic binder and acrylic paint to make your own paste – either directly on the canvas, on a palette, on a plate or in a plastic bowl.

Marble powder

Amongst other things, marble powder is used for stencilling. Unlike paste, it does not produce unattractive shades of pink when mixed with red acrylic paint.

Acrylic binder

Acrylic binder is used to prime canvas, as an adhesive for grasses, ferns and so on and, combined with sand and marble powder, to make paste.

Stencils

You will find a selection of stencils in lots of different motifs, and made from various materials, in art supply shops.

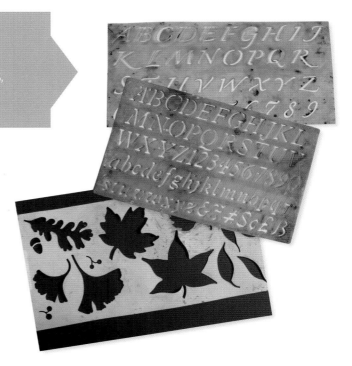

Pressed bark

Art suppliers sell pressed bark in sheets of different sizes and various shades of brown.

Canvas as a paint palette

Prepare a piece of canvas for your paint palette so you can mix your paints on it. This is a practical and inexpensive alternative to a traditional palette.

PAINTING TECHNIQUES

The following is an overview of my preferred painting techniques. There are lots of ways to experiment with materials and painting media. Just try the various techniques for yourself – your attempts will help you create your own individual, unmistakeable style. Your 'trademark' will develop almost by itself over time.

Using mixed media

Any kind of painting that uses more than one medium – for instance, acrylic paints and acrylic watercolours – is called mixed media. This includes the simultaneous use of sand, conventional paper, leaves, wood offcuts and much more.

I do not always plan to use mixed media when I'm starting a picture. Sometimes it arises out of my dissatisfaction with a picture. For instance, if a watercolour is a little dark, I can use acrylic paints to lighten it (see page 81).

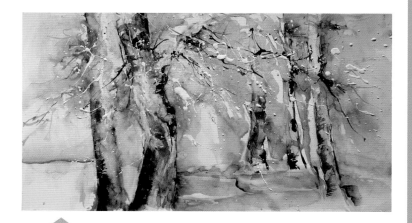

The trees are painted in watercolour and acrylic paints; the background in watercolour paint only. I sprayed on the snow in white acrylic paint using a bristle brush.

Tree Landscape in Winter, mixed media, 50 x 60cm (19¾ x 23½in)

Colour application methods

Priming: Priming prevents the painting base from absorbing too much paint. There are different ways of priming a canvas. I use acrylic paints to keep things simple and to give the picture a particular shade from the outset.

Glazing: A glaze is a layer of paint (watercolour, acrylic or Aquacryl) diluted very thinly with water and painted over the picture. The paint layers beneath the glaze shimmer through subtly, which adds depth to the painting, and also creates an exciting atmosphere. Acrylic paints can be applied in several layers of glazing, allowing each one to dry between applications, as the individual layers are not water-soluble.

Shake and spray: For a dynamic effect, dilute acrylic paint with water and shake over the painting. If you want to dilute the paint even more, use a spray bottle.

Palette knife: Applying paint and paste with a palette knife adds dimensionality and structure to your picture (see page 20).

Spraying: This technique is ideal if you want to reproduce the delicate stamens of flowers. Dilute paint with water. Dip a bristle brush into the diluted paint, and run your finger over the bristles in the appropriate place on your painting. A round brush is better if you want to make larger splatters. Tap lightly on the brush handle.

Dotting: Dotting lightly indicated poppy or grass seed pods creates an exciting contrast with the more precisely painted central motif.

Watercolour painting style

Acrylic paints, as well as watercolours, can be diluted very thinly with water and painted in a glaze. This allows you to use traditional watercolour techniques with either of these media. When using acrylics with this technique, wait until the painting is dry before applying a new layer of diluted paint. This prevents too many different colours merging with each other and creating dirty patches. This 'watercolour technique' gives a picture a very light, free and spontaneous character that is traditionally associated with watercolour paintings.

Top right: *Bunch of Poppies*, watercolour, 60 x 60cm (23½ x 23½in)

Bottom left: *Blue Iris*, acrylic, 70 x 70cm (27½ x 27½in)

Bottom right: *Autumn Poppy*, acrylic, 70 x 70cm (27½ x 27½in)

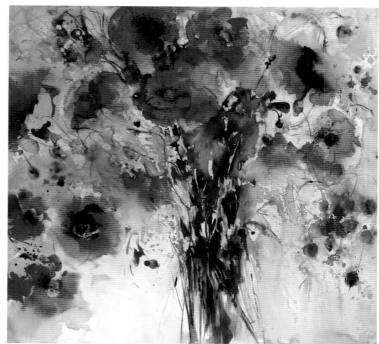

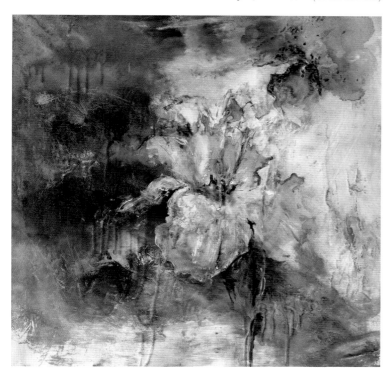

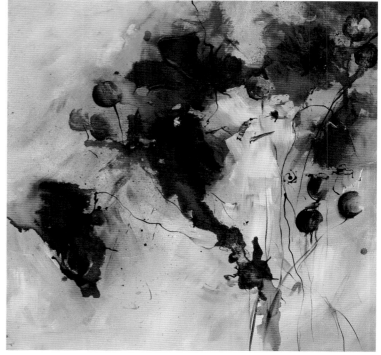

Using a spatula

There are lots of different ways of working with a spatula. I like to use a rubber spatula, since this results in softer transitions between the colours. By contrast, a plastic spatula creates stronger structures with the applied paint. I prefer a palette knife for larger, slightly coarser shapes. A palette knife can also be used to apply paint very thickly.

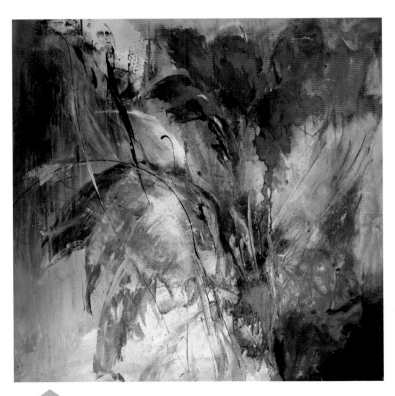

I worked the background and leaves with the rubber spatula, and the flowers using a large palette knife.

Amaryllis, acrylic, 70 x 70cm (27½ x 27½in)

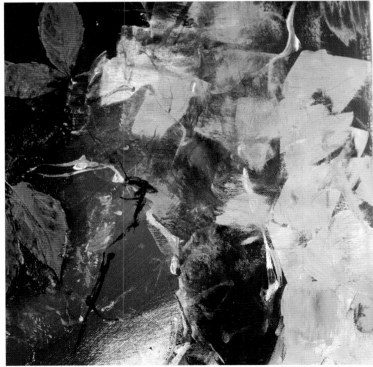

I applied the background to the right of the vine using a rubber spatula.

Detail from *Virginia Creeper in Winter*, acrylic, 70 x 70cm (27½ x 27½in)

Collages and structure

Using natural materials will create a very special effect within your pictures. Try using fresh leaves, grasses and ferns, as they will create stronger structures than dried, found objects. If you're wondering where I find these natural materials in winter, I have a green fern in a clay pot in a cool corner of my art studio. On my walks, I collect fallen bark from various different trees and keep it in a cool place (such as the basement) until needed. You can also obtain grasses and leaves from a nursery.

The topic of structuring is one that can be discussed almost endlessly. I am sure it will also fascinate you if you go into it in some depth. Structure help you to give your paintings more dimensionality. A good art supply shop will provide you with more diverse materials that you can use to add structure to your pictures.

Dried leaves tend to look flat, and may fall apart the first time you paint over them. This can be avoided if you brush the leaves well with acrylic binder so they are completely sealed in.

Detail from *Vine Leaf*, acrylic, 20 x 30cm (7¾ x 11¾in)

Applying plant materials directly

The following pages show you how best to use natural materials. As already mentioned in the chapter on additional materials (see page 14), acrylic binders are very good for gluing on natural materials.

It is tempting to want to preserve the pretty, natural colours of leaves, ferns and tree bark. Although acrylic binders create an airtight seal, I have had to accept that natural colours still change over time, becoming a rather unattractive shade of brown.

Detail from *Natural Ferns*, acrylic, 70 x 70cm (27½ x 27½in)

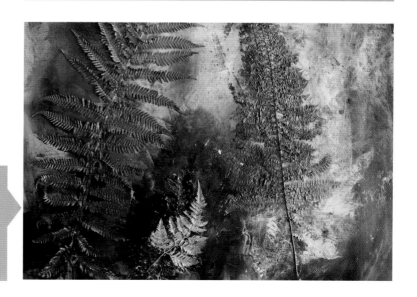

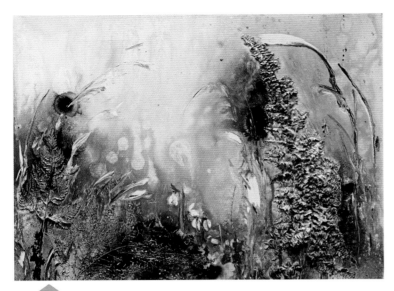

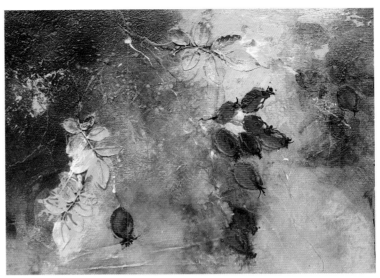

The best way to prevent a change in colour is by over-painting the collage materials on your picture with acrylic paint once they are completely dry.

Detail from *Painted Ferns and Grasses*, acrylic, 50 x 50cm (19¾ x 19¾in)

You can also paint smaller leaves in acrylic paint first and then continue to use them. For this picture, I painted rose leaves in green acrylic paint and then stuck them onto the painting surface.

Detail from *Rose Leaves with Rose Hips*, mixed media, 10 x 15cm (4 x 6in)

Stamp-printing with natural materials

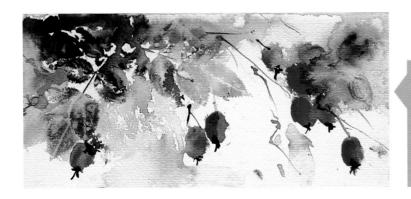

Another option for utilising nature's treasures in art is to paint leaves, grasses or ferns on one side and then press them onto the painting surface like a stamp. I used rose leaves in the example shown here.

Detail from *Red Rose Hips*, mixed media, 10 x 15cm (4 x 6in)

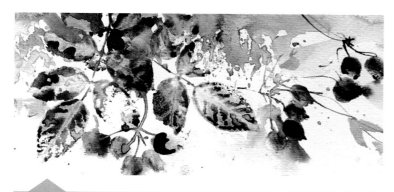

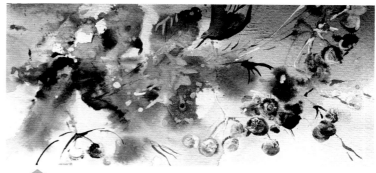

Paint rose leaves with plenty of green watercolour paint, then press them down firmly on thick watercolour paper. Paint the rose hips in watercolour paint as well. Use airbrush and Aquacryl paints for the darker shadows.

Detail from *Pink Rose Hips*, mixed media, 10 x 15cm (4 x 6in)

Change the colours a little, and you will have some lovely variations in pale pink, pale blue and many others.

Detail from *Blueberries*, mixed media, 10 x 15cm (4 x 6in)

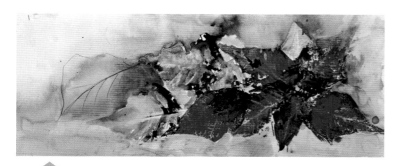

The leaves of a poinsettia are strikingly shaped, and are easy to work with.

Poinsettia, mixed media, 10 x 25cm (4 x 9¾in)

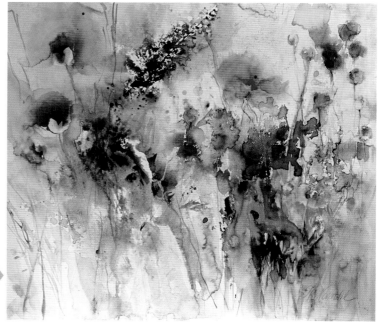

Ferns are also easy to paint and print.

Detail from *Flower Meadow with Fern Prints*, mixed media, 50 x 60cm (19¾ x 23½in)

Working with paste

Paste is available in a range of consistencies from art suppliers. However, it is also easy to make your own paste from sand, marble powder and acrylic binder (see page 14). This mixture is a shade of grey that you can use in your pictures with confidence.

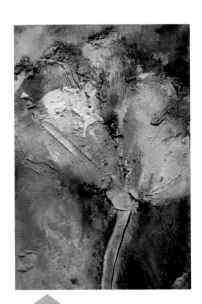

This flower was made with sand and white acrylic paint. Once it had dried I painted over a few areas only. Of course, you can also combine any other colour with the sand. This will result in shades that you cannot produce with acrylic paint alone.

Detail from *Lilac and White Flower*, acrylic, 30 x 100cm (11¾ x 39¼in)

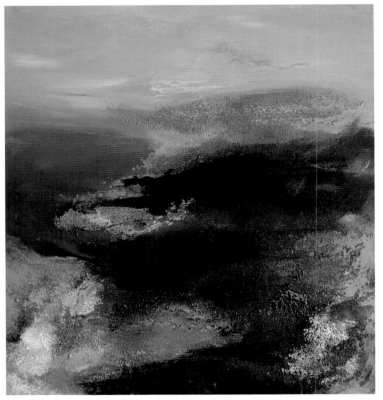

This kind of paste is also excellent for creating landscapes.

Landscape, acrylic, 80 x 80cm (31½ x 31½in)

For this motif, I combined lime green and fine sand for the lighter leaves, and Hooker's green with black for the darker leaves.

Detail from *Red Flowers*, acrylic, 60 x 60cm (23½ x 23½in)

A ready-made fine paste or heavy body acrylic paint is suitable for the structure of several tree trunks. If the paste is too coarse, the trunks will soon look clumsy.

Detail from *Autumn Forest*, acrylic, 80 x 100cm (31½ x 39½in)

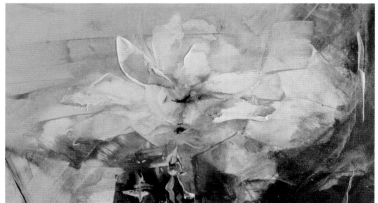

Paste can emphasise the structure of the bark on a single tree trunk effectively.

Detail from *Tree Trunk*, acrylic on paper, 30 x 60cm (11¾ x 23½in)

Heavy body acrylic paint is used for the shapes of these airy, white flowers. The consistency of this paint is ideal for creating delicate petals.

Detail from *White Lily*, acrylic, 70 x 70cm (27½ x 27½in)

Experimental techniques

You have probably experienced it yourself: you're out on a walk, see something pretty, and want to take it home and keep it. On the following pages, I show you how you can use natural souvenirs – sand, for instance – to create a permanent reminder of your last holiday.

Let your imagination run wild, and try experimenting with more unusual materials!

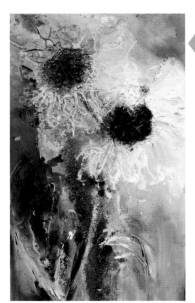

I used real rose petals for this sunflower. I applied thick, brown acrylic paint with a spatula for the centre of the flower. I then sprinkled ground bark mulch from the garden on top, and pressed it down well.

Detail from Sunflowers, acrylic, 50 x 100cm (19¾ x 39½in)

Again I used ground bark mulch here and then added some soil.

Tuscany Landscape, acrylic, 40 x 80cm (15¾ x 31½in)

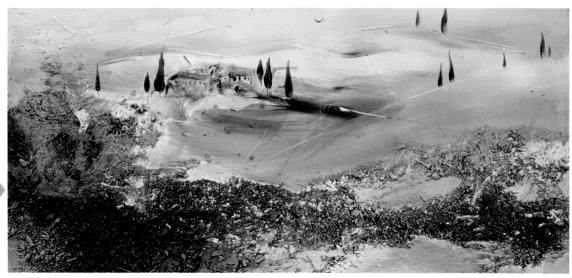

Sand brought home from a holiday is ideal for sprinkling over landscapes – or it can be used as a decorative frame.

If the sand is a very distinctive colour – I used black-grey sand from Tuscany here – it will look more attractive if you sprinkle it straight over the acrylic paint and do not paint over it. Find out on pages 96–99 how to reproduce this picture.

Detail from *Virginia Creeper in a Grey Frame*, acrylic, 70 x 70cm (27½ x 27½in)

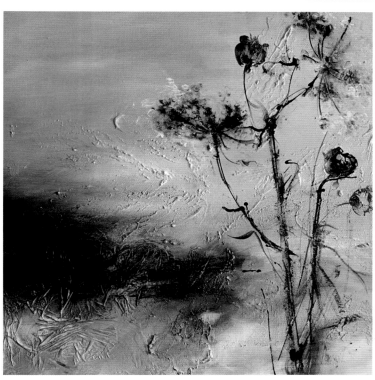

You can also add an interesting structure to your picture with tissue or newspaper. Mountain formations and landscapes are ideal motifs.

Left and right: *Landscape in Blue*, acrylic, 80 x 80cm (31½ x 31½in)

Working with spray varnish

You will achieve a surprising effect if you use black spray varnish (see page 12).

Proceed as follows to reproduce the effect shown in the picture on the right. Prime your canvas with acrylic paint in lemon yellow. Dilute lime green and white with water. Shake the paint over the left side of the picture and spray with plenty of water. Turn the picture so the paint runs in the desired direction. Next, apply black spray varnish generously over the green and white areas while they are still wet. The varnish will not bind with the paint, but will create random, abstract patterns. When it is dry, paint the grasses on the right side of the picture.

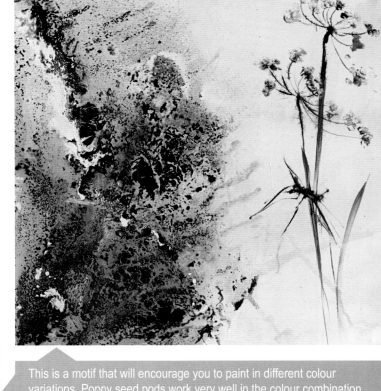

This is a motif that will encourage you to paint in different colour variations. Poppy seed pods work very well in the colour combination red, yellow and black.

Top: *Abstract Yellow*, acrylic, 70 x 70cm (27½ x 27½in)

Bottom: Detail from *Abstract Red with Poppy Seed Pods*, watercolour, 50 x 60cm (19¾ x 23½in)

A tip from my art studio:
What to do with leftover paint

It's not unusual to be left with quite a lot of paint when you finish a painting. Rather than throw it away, use it for small pictures or cards.

Carefully press a sheet of watercolour paper weighing about 300gsm (140lb) onto the canvas palette with the leftover paint and move the paper back and forth. You will be left with 'mini abstracts' in wonderful colour combinations that you would not be able to create with a brush.

You can continue working on these little pictures, perhaps painting a flower in a blank area, or you could turn one into a Christmas card. Use a gold or silver pen to add stars or Christmas trees to your picture.

Top: Detail from *Floral Print*, acrylic on paper, 7 x 15cm (2¾ x 6in)

Bottom: Detail from *Christmas Note Card*, acrylic on paper, 10 x 15cm (4 x 6in)

INSPIRATION

The topic of 'inspiration' is intimately connected
to painting. Many painters eventually arrive at a point in
their creative careers where they simply run out of ideas
and inspiration. If you find yourself in this situation,
I recommend a relaxed walk amongst nature. You'll soon
be enjoying the benefits! Nature will never disappoint
you with her variety of colours and motifs, and you will
feel stronger and more inspired when you return home.

Sources of inspiration

The attraction of flowers and trees is due to the much-quoted 'miracle of nature'. However, the very moment in which we experience nature is fleeting. If we want to share it, we have to find a way to hold onto it.

I wanted to capture nature's beauty for myself and for my family, particularly that of the seasons when nature is at rest. This desire encouraged me to reach for my brush.

At first I tried to reproduce nature, to capture her in work that would later be seen by others. It was important to me that my pictures should inspire like-minded people to experience nature 'through the brush', as it were. But first you have to learn to understand nature: how do flowers and trees grow; how are they constructed, and how do they change with the seasons? Lots of walks, lots of photographs and a preoccupation with the detail of your subjects will enable you to reflect nature in a wide range of paintings, abstract or true-to-nature.

It is only when you look at an object closely, occupy yourself repeatedly with a single tree or a shrub, that you will start to understand specific shapes and colours, and notice how the urge towards creativity is kindled within you. In order to experience the complete development of a flower – from the bud to the full bloom – it is often necessary to walk the same route to your particular spot on several successive days.

The variety of trees is not only seen in the differentiation between deciduous and coniferous types. Tree growth, the formation of the branches, the shapes of the leaves, the way the roots intertwine, the bark structures left by the weather, and the annual change in the colours of the leaves: all provide wonderful motifs.

If you do not just walk past the beauty of flowers and trees, but take the time to look at them with new eyes, you will not only feel enriched and invigorated, you will also find your muse within you.

Of course, long outdoor walks are only one of my sources of inspiration. I often look through my large collection of books on gardens and flowers, and I like looking at calendars and pretty cards. The internet also offers access to a vast store of nature photographs.

Developing techniques in a small niche in which other artists are perhaps a little less successful will increase your individuality as a painter. You will have something that sets you apart from everyone else, something that makes your work distinctive and unmistakeable.

With this book, I would like to encourage you to paint, and to support you in your artistic development. If, in time, you have developed your own artistic style, hopefully an increasing group of art lovers will become aware of this. Seeking artistic exchanges with others will also deepen your experiences while painting!

Top right: Detail from *Poppy*, acrylic, 30 x 30cm (11¾ x 11¾in)

Centre left: Detail from *Roses*, watercolour, 50 x 60cm (19¾ x 23½in)

Bottom right: Detail from *Ox-eye Daisies*, watercolour, 40 x 60cm (15¾ x 23½in)

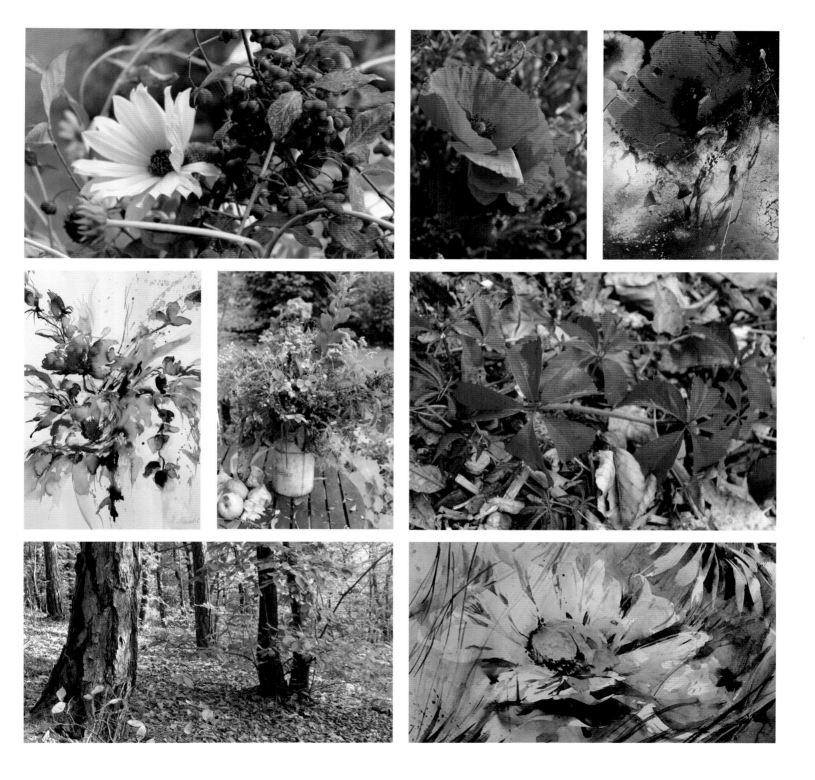

Inspiration throughout the year

Flowers

Every season has its own flowers, and they are generally considered to be the loveliest stage in a plant's life. For instance, most people are thrilled if someone gives them a delicate orchid as a gift.

To me, however, the flowers and plants that I can experience in their natural surroundings are more important as motifs for my pictures.

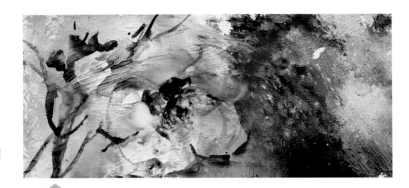

Equipped with a camera, I set off in January to seek the first hellebores.

Detail from *White Flower*, acrylic on paper, 10 x 15cm (4 x 6in)

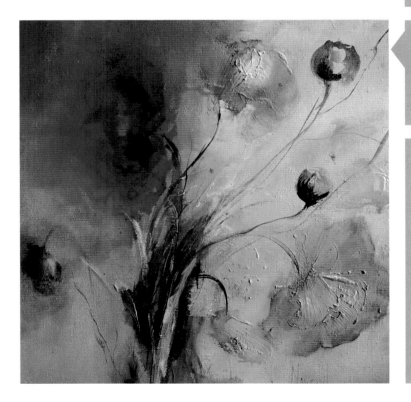

Soon afterwards I see the first snowdrops, then the early tulip varieties, the egg yolk-yellow dandelion and its transformation into a glassy-white, fragile 'clock'. Not forgetting the abundance of delicate poppies, the pretty flowers followed by the strong seed pods...

Iceland Poppy, acrylic, 80 x 80cm (31½ x 31½in)

...Ox-eye daisies in my garden, a few water lilies in the mini biotope next door, gladioli in a wide range of colours; roses, of course, and then, before the typical autumn flowers such as dahlias, asters and chrysanthemums are seen, I witness a wide variety of sunflowers.

Detail from *Ox-eye Daisies*, watercolour, 50 x 60cm (19¾ x 23½in)

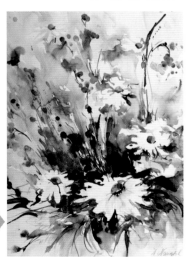

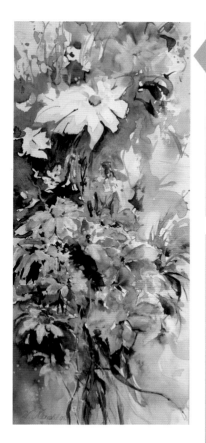

I have paid particular attention to the smaller and rather basic forms of the poppy, the ox-eye daisy and the sunflower. They might not be as graceful as a rose or lily, but they are every bit as impressive and perhaps even more original.

Detail from *Bouquet of Ox-eye Daisies*, mixed media, 30 x 60cm (11¾ x 23½in)

The tremendous range of shapes and colours of flowers covers the entire spectrum perceived by the human eye. Flower motifs, painted in watercolour, are brought to life by the colours flowing into each other, and the soft transitions between them.

Detail from *Amaryllis*, watercolour, 50 x 60cm (19¾ x 23½in)

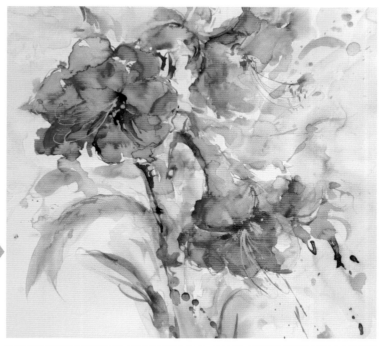

My aim is to create pictures of flowers as reflections of nature in bright, flowing colours – to reproduce the glow of the individual flowers, rather than their exact shape.

Flower Meadow, acrylic, 80 x 80cm (31½ x 31½in)

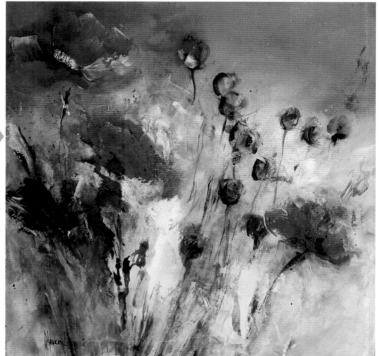

Trees

The artist seeking a motif will find inspiration in more diverse tree landscapes – perhaps those that are mysterious, or powerful, or maybe damaged by fire or clearing. You will see inspiration in trees of unimaginable age, dense pine forests, vast mixed woods and – a very popular motif – the constantly changing deciduous tree.

Enjoy the simple coming and going of the seasons. The documentation of the gradual changes in nature is particularly successful on the artist's canvas.

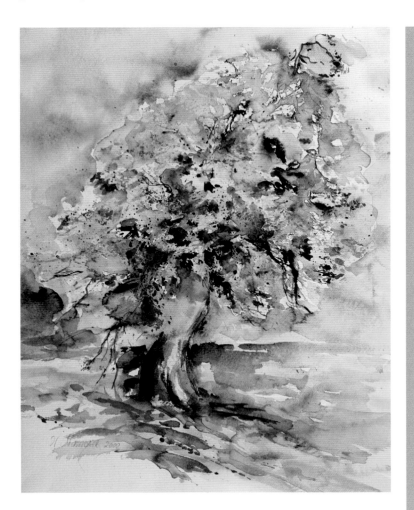

A tip from my art studio:

A picture that works well in watercolours can often also be executed in acrylics. The majesty and movement of trees can be reproduced much more successfully on a large canvas in acrylic paints.

In spring

In spring, it's time to look out for the first splashes of colour between the slender birches in the garden or to admire the bright green of magnificent chestnut trees.

A gnarled old cherry that still manages to produce a pink-and-white froth of blossom glows with vitality and brightness. It is complemented perfectly by the silky-blue sky as a sign that it is time for the vegetation to sprout.

A stroll through the spring air will bring you face to face with almost countless groups of flowering fruit trees with pale or bright pink buds. At this time of year, the variety of subjects leaves the artist spoilt for choice. Delicate colours and growing shapes will enable you to illustrate nature's awakening in spring.

◀ Left: *Flowering Fruit Tree*, mixed media, 50 x 60cm (19¾ x 23½in)

▶ Top left: *Birch Trees in Spring*, acrylic, 80 x 80cm (31½ x 31½in)

▶ Top right: Detail from *Tree Abstract in Green*, acrylic, 50 x 60cm (19¾ x 23½in)

▶ Bottom left: Detail from *Spring Tree*, watercolour, 50 x 60cm (19¾ x 23½in)

▶ Bottom right: Detail from *Tree-lined Avenue in Spring*, mixed media, 50 x 60cm (19¾ x 23½in)

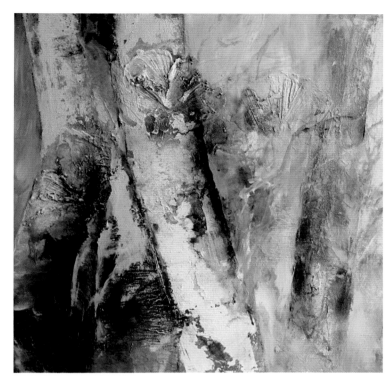

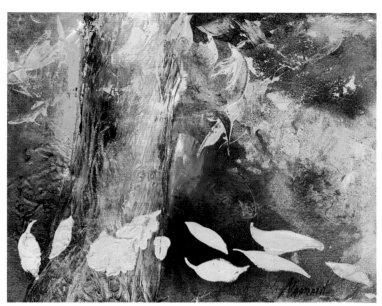

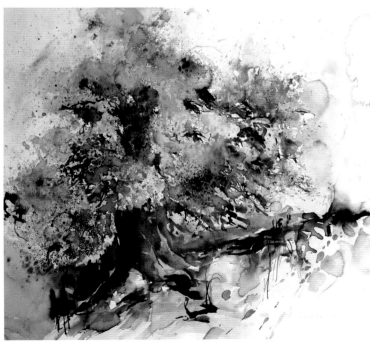

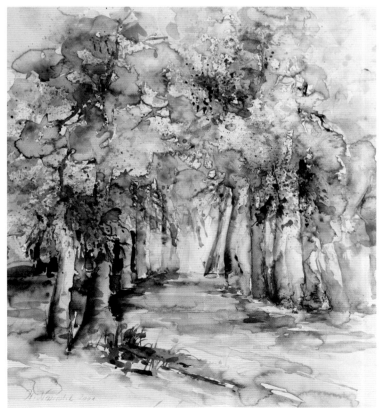

In summer

In summer, narrow paths lead me between the trees, encouraging me to study their trunks, the growth and weather in the various bark textures.

The rich fragrance of the damp, sprouting, moss-green grass invites me to take a little of it home with me and use it in my painting.

Strong sunshine penetrates the tree landscape, brightening up a forest meadow in a rich, dark green. I am only too happy that I can finally enjoy art outdoors.

Now all I need is to take on nature's boldness in its intense colours and, in many different ways, to develop it, and reflect it in my own pictures.

▶ Top: *Birch Alley in Summer*, watercolour, 50 x 60cm (19¾ x 23½in)

▶ Bottom: *Summer in the Forest with Fern*, acrylic, 80 x 80cm (31½ x 31½in)

▼ Bottom left: *Summer Meadow*, mixed media, 50 x 60cm (19¾ x 23½in)

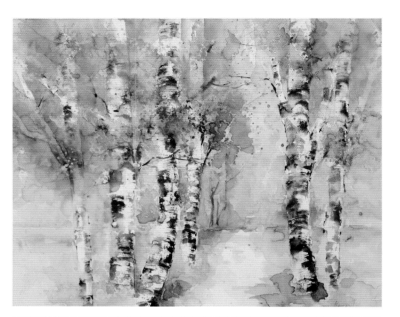

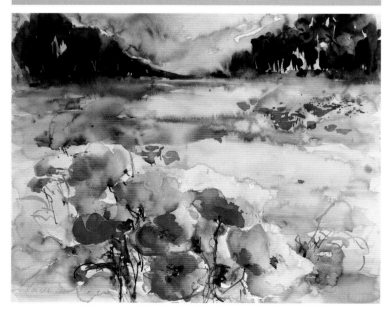

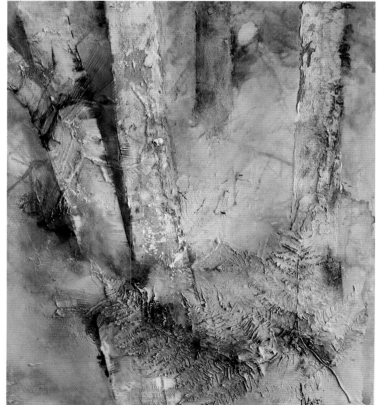

In autumn

Walks through the crunchy, brightly coloured leaves and golden light penetrating the mist on an autumn morning prove that the season still retains life and energy.

Out and about with my camera, I develop the desire to capture these fabulous impressions in a painting.

Golden leaves, bright orange leaves, ruby-red leaves – many of the trees are truly at their very best. The variety of colours encourages the artist to capture them one last time in paint and painting techniques.

Rotting plants – the odd ones here and there at first, then becoming more numerous – tell us that winter is approaching. Days glowing in the rich colours of late autumn flare into life one last time. The Virginia creeper bears attractive blue-red berries; the last leaves fall to the autumnal ground like golden flames.

Before winter declares it has won the battle, there's one last picture for the wine cellar: a vine, either full of bright grapes, or one that has recently been harvested, painted in strong colours.

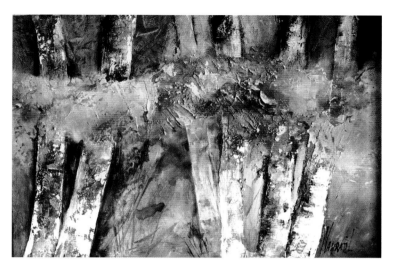

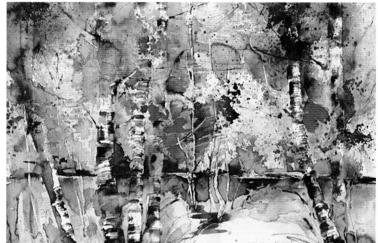

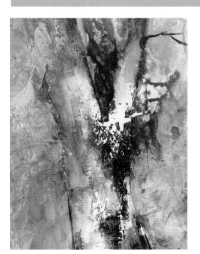

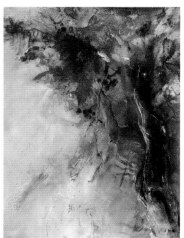

▲ Top: *Fiery Autumn*, acrylic, 80 x 100cm (31½ x 39½in)

▲ Bottom: Detail from *Path through the Autumnal Birch Forest*, watercolour, 50 x 60cm (19¾ x 23½in)

◀ Left: Detail from *Autumn Sunshine*, acrylic, 60 x 90cm (23½ x 35½in)

◀ Right: Detail from *Vine in Autumn*, acrylic, 80 x 80cm (31½ x 31½in)

In winter

Winter is not without its colours – but we also need the various shades of grey and black. The coarse white of snow-covered mountains, smiled on by the sun, stimulates skiers and boosts their energy. Light has amazing colours even in winter, and they are especially strong in the glowing snow.

I feel the coldness of the forest lake that I circle on my walk, already frozen over in some places; a touch of frost in the air illustrates my every breath. Reflections and shadows accompany and fascinate me: impressive moments in what is supposedly the quietest season. Excursions into the vast green pine forest or strolls through leafless, deciduous forests deserve to be captured in paint.

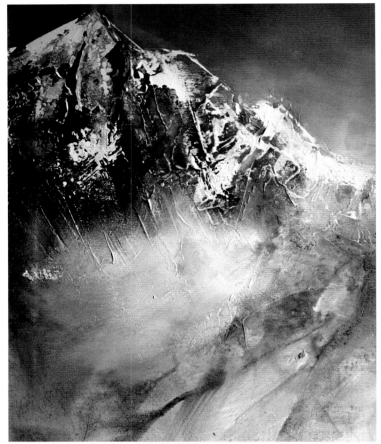

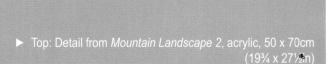

▶ Top: Detail from *Mountain Landscape 2*, acrylic, 50 x 70cm (19¾ x 27½in)

▶ Bottom: Detail from *Winter Landscape*, mixed media, 40 x 50cm (15¾ x 19¾in)

▶▶ Right: *Winter by the Lake*, acrylic, 80 x 100cm (31½ x 39½in)

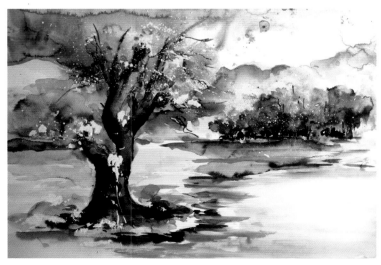

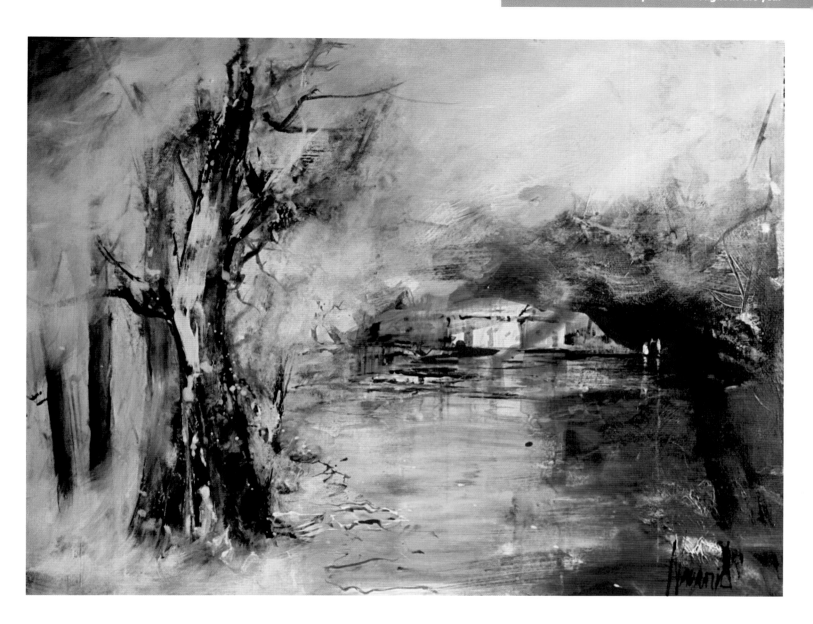

THROUGH THE SEASONS WITH FLOWERS AND TREES

Now that you have learnt a little bit more about materials, painting techniques and sources of inspiration, you are ready to start painting! This section follows the course of the seasons, and you will see differences in the motifs and in the chosen colours.

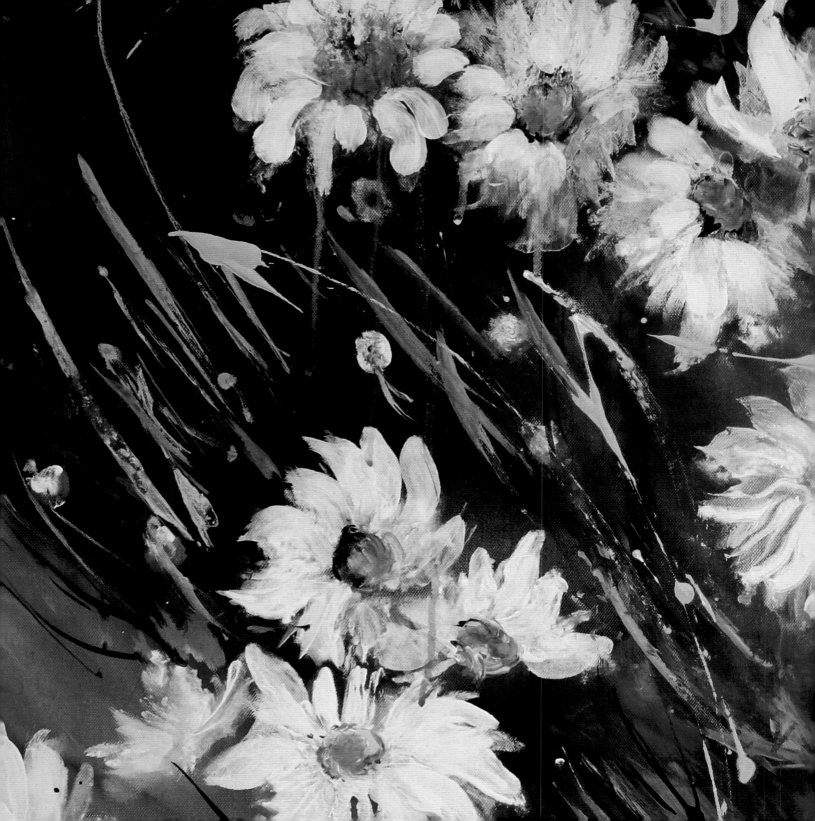

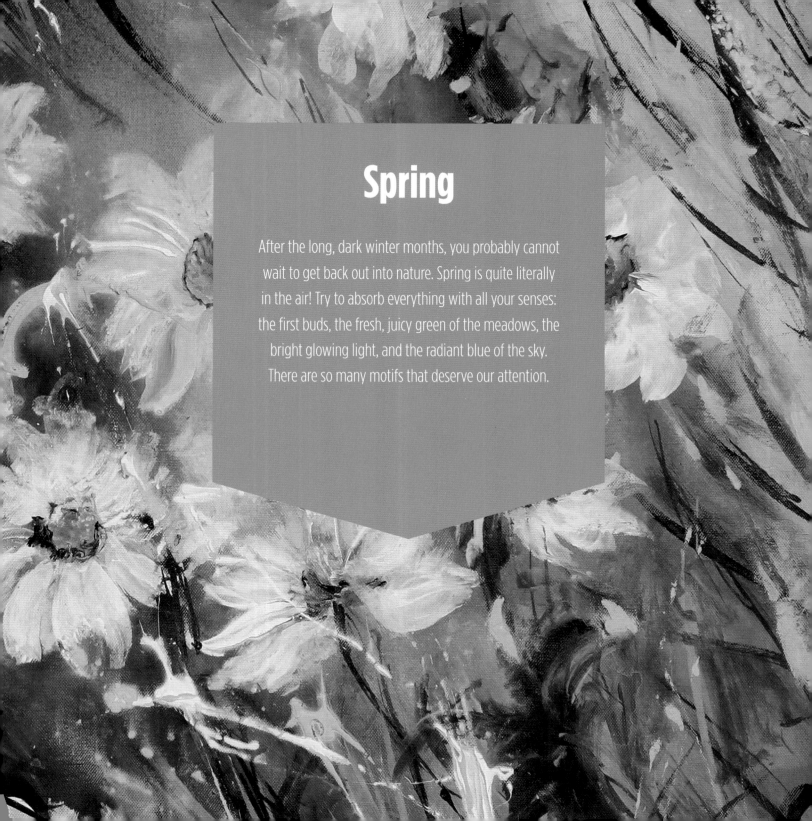

Spring

After the long, dark winter months, you probably cannot
wait to get back out into nature. Spring is quite literally
in the air! Try to absorb everything with all your senses:
the first buds, the fresh, juicy green of the meadows, the
bright glowing light, and the radiant blue of the sky.
There are so many motifs that deserve our attention.

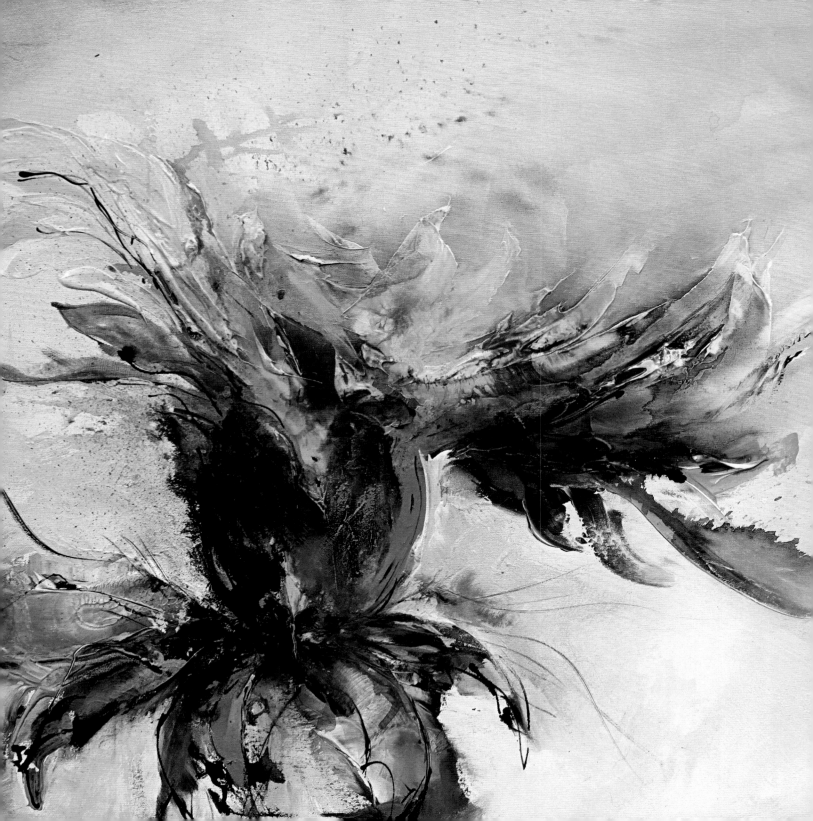

Flowering Dandelion

Materials

Square canvas, e.g. 80 x 80cm (31½ x 31½in)
Acrylic paint in cobalt blue, lime green, white
Aquacryl paint in medium yellow, permanent yellow, lemon yellow
Airbrush paint in Brazil brown, deep madder, olive brown, olive green
Flat brush, angled brush, palette knife
Spray bottle of water

Step by step

1 Prime the canvas in white acrylic paint using a flat brush. Then use a thin palette knife to add the flowers in thick white, the bud and leaves in lime green and white.

2 Once dry, glaze the background in white, then paint the top and bottom with a little cobalt blue mixed with lots of white. Now apply lemon yellow Aquacryl paint generously to the leaves, and spray the colour with water to spread. Leave to dry.

3 Apply medium yellow Aquacryl paint to the petals, and again spray with water. Blend the airbrush colours olive brown and olive green, then dilute them with a little water and allow to run over the bud and the leaves beneath it. Let a little of the paint flow into the yellow petals.

4 Apply a little of the airbrush paint in Brazil brown to the undersides of the petals, then to the left of the bud and at the transitions to the petals to shade. Paint Aquacryl paint in medium yellow to the lower leaves and allow a little of the airbrush paint in deep madder to flow into them and shape the leaves. Dip the angled brush in Brazil brown and paint the tips of the leaves dynamically.

5 Finish the middle of the flower in permanent yellow Aquacryl paint, and spray with water to spread the paint.

◄ *Flowering Dandelion*, acrylic, 80 x 80cm (31½ x 31½in)

▶ Detail: The colours merge gently, adding a very special dynamic to the painting.

Poppy and Wild Cumin

Materials

Square canvas, e.g. 80 x 80cm (31½ x 31½in)
Acrylic paint in Hooker's green, cadmium orange, lime green, primary yellow, black, white, lemon yellow
Aquacryl paint in permanent red
Airbrush paint in deep madder, olive brown, olive green
Fine sand
Flat brush, angled brush, line brush, palette knife, spatula
Spray bottle of water

◀ *Poppy and Wild Cumin, acrylic,*
80 x 80cm (31½ x 31½in)

▶ Source photograph: I painted the picture from this photograph. What would happen if you finished the painting described above, then ignored the instructions and painted your very own interpretation? How different would this picture be from the earlier one?

Step by step

1 Using a small spatula, shape one poppy in primary yellow, and the other one in cadmium orange. Prime the background in white and lemon yellow, then use the flat brush to blur the edges of the flowers with the background.

2 Mix the airbrush colours olive brown and olive green with acrylic paint in Hooker's green. The result is a warm shade of olive. Add a little fine sand to it. Apply this mixture with a large palette knife to shape the leaves and grasses in the background.

3 Mix Hooker's green with more sand, add a large blob of white and, without folding in the white, apply to the canvas in jerks with the palette knife to create the shape of a leaf. Leave until completely dry.

4 Mix together white and lemon yellow, and use to intensify the background. Leave until dry.

5 Paint light spots of lime green with the flat brush to illustrate the different shades of the grasses, and spread on a little primary yellow with the spatula to add light reflections. Now shape the wild cumin and a few grasses in green and black with the line brush.

6 Dot on the dark spots of the cumin flowers with your fingertips. Shape the tiny white flowers loosely with your fingers.

7 Shade the two poppies at the end using the angled brush with airbrush paint in deep madder and Aquacryl permanent red. Spray a little water onto the flowers, and carefully let the red paint run to the outside.

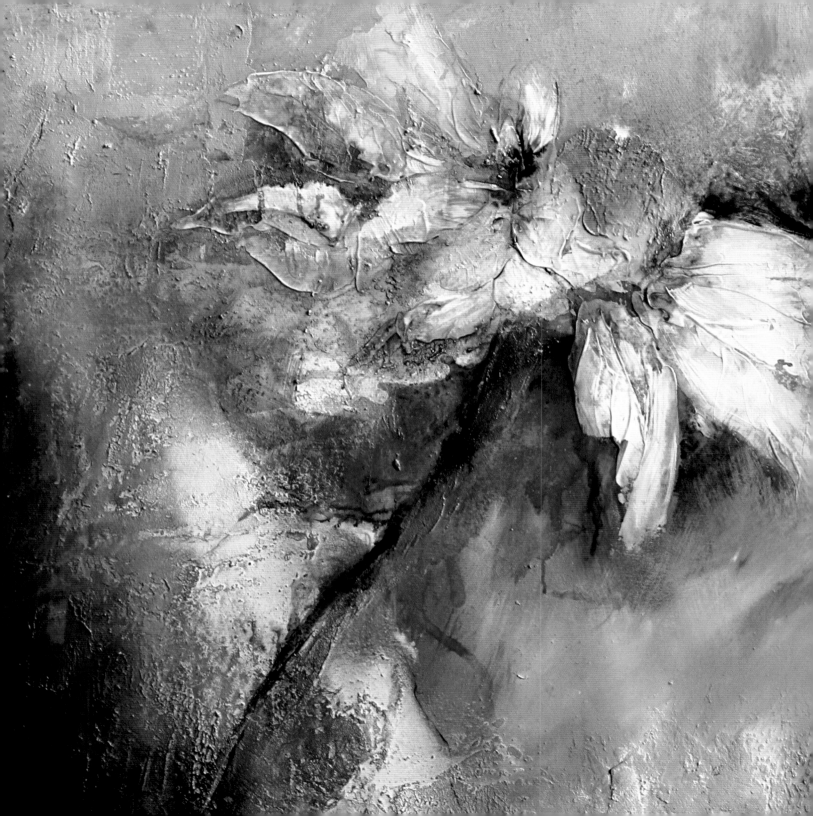

Ox-eye Daisy

Materials

Rectangular canvas, e.g. 80 x 100cm (31½ x 39½in)
Acrylic paint in Hooker's green, indigo, royal blue, Prussian blue, black, white, lemon yellow
Heavy body acrylic paint in white
Aquacryl paint in medium yellow, permanent yellow
Airbrush paint in olive brown, olive green, sepia
Acrylic binder, fine sand, marble powder
Flat brush, angled brush, palette knife, spatula
Spray bottle of water

◄ Ox-eye Daisy, acrylic, 80 x 100cm (31½ x 39½in)

▲ Detail: Paste on the petals in heavy body acrylic paint. Then apply airbrush paint in sepia and spray with water to reinforce the characteristic leaf shape.

Step by step

1 Start by pasting on the ox-eye daisy in white heavy body acrylic paint. Then combine acrylic binder, fine sand and marble powder to make a paste, and add it to parts of the canvas with the palette knife. Make sure you use this paste to add accents: you will instinctively know where there is something missing, and when you should stop. While you are applying the paste, vary the pressure on the palette knife to create different shapes and textures. Let the picture dry.

2 Add a few dots of sepia airbrush paint to the petals and spray with water. The paint will settle in the indentations, so the petals are shaped almost automatically.

3 Prime the entire background in white acrylic paint.

4 When dry, glaze in various shades of blue. Again leave to dry.

5 Mix Prussian blue with black, and apply to the bottom left to add the focus of the picture. Apply royal blue from above to create a soft transition. Paint dark shadows under the ox-eye daisy in Prussian blue and airbrush paint in olive brown mixed with a little olive green.

6 Mix olive brown airbrush paint with Hooker's green acrylic paint to make a dark green. Then use a thin flat brush to paint the stalk of the ox-eye daisy, and spray it lightly with water. Turn the picture to allow the paint to run.

7 When dry, allow thinly diluted white acrylic paint to run over parts of the picture. Again leave to dry.

8 Shape the middle of the ox-eye daisy in lemon yellow. When dry, glaze in medium yellow Aquacryl paint. Leave to dry.

9 Drip a little Aquacryl paint in permanent yellow onto the flower and spray with water. Using the angled brush, paint dark shadows to highlight the flower a little more, and add white accents to the petals.

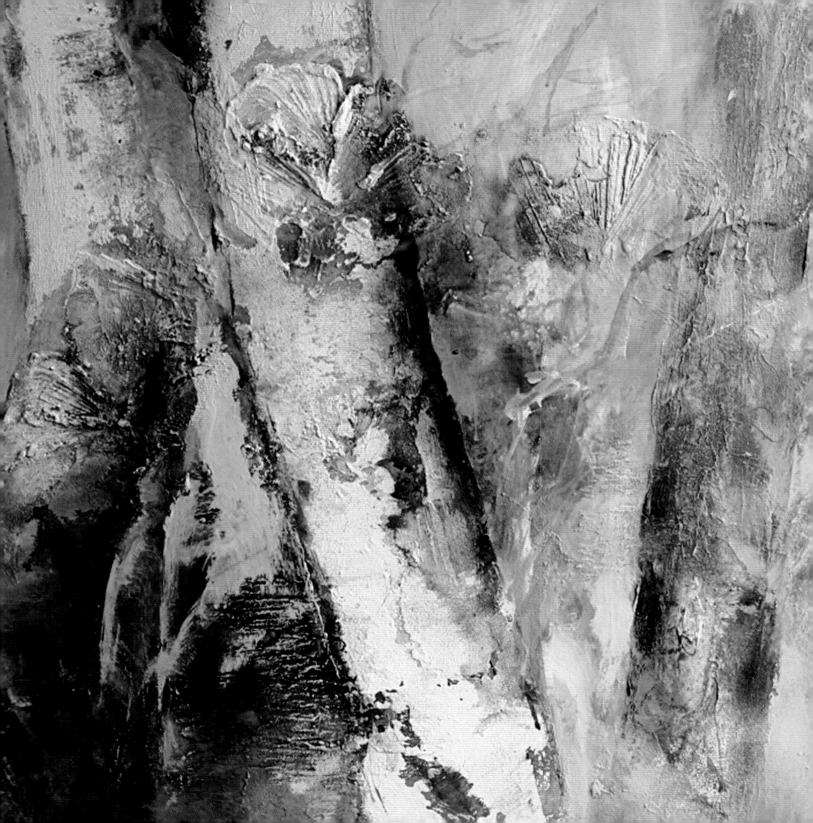

Birch Trees in Spring

Materials

Square canvas, e.g. 80 x 80cm (31½ x 31½in)
Acrylic paint in Hooker's green, cobalt blue, light blue, turquoise, white
Aquacryl paint in medium yellow, permanent yellow
Airbrush paint in olive brown
Fine paste
Sand
Flat brush, angled brush, palette knife, spatula

Step by step

1 Prime the canvas from the top down in cobalt blue acrylic paint, and from the bottom up in Hooker's green. Combine white with a little sand, and apply to areas of the canvas with the spatula to create the background. Apply the fine paste with the palette knife to shape the trunks. Apply the paste irregularly so that a little of the background can still be seen.

2 Take the flat brush and mix the cobalt blue with a little white. Use to complete parts of the background. Do the same on certain parts in turquoise. The result is a pretty, spring-like mood.

3 When dry, paint a few sunny areas in medium yellow and permanent yellow Aquacryl paint. Shade the trunks in olive brown airbrush paint to add more depth.

Let a little of the olive brown flow into the background.

4 Finally, using the angled brush and light blue acrylic paint, add hints of a few branches.

◄ *Birch Trees in Spring*, acrylic, 80 x 80cm (31½ x 31½in)

► Detail: The mixed paste, the lightly indicated blue branches and various spring colours converge in the centre of the picture. The result is a fresh, warm mood.

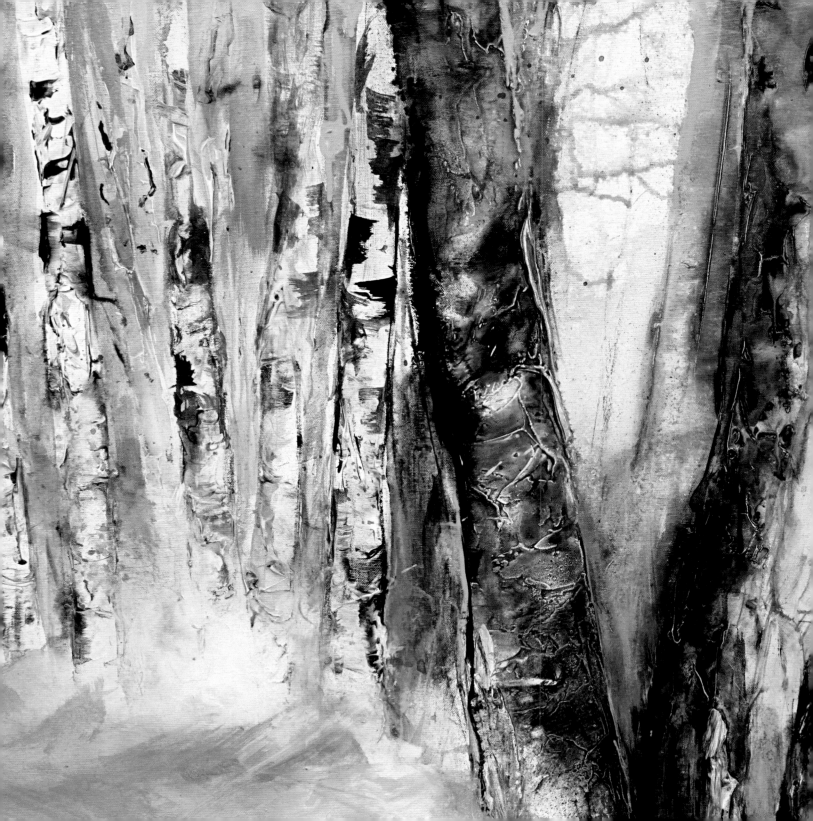

Spring Mood in the Forest

Step by step

Materials

Rectangular canvas, e.g. 80 x 100cm (31½ x 39½in)
Acrylic paint in turquoise, white, lemon yellow
Heavy body acrylic paint in white
Aquacryl paint in medium yellow, permanent yellow
Airbrush paint in sepia
Flat brush, angled brush, line brush, palette knife
Spray bottle of water

1. Mix white with lemon yellow and prime the canvas. Outline the trees with sepia airbrush paint using the line brush, and apply the tree trunks in heavy body white acrylic paint with the palette knife. Leave until completely dry.

2. Now apply sepia airbrush paint to the two tree trunks at the front. Spray water onto the trunks and turn the canvas so that the paint can settle in the indentations.

3. For the rest of the trees, use the angled brush to shade the trunks in sepia. Leave to dry.

4. Dilute the turquoise acrylic paint with water, and paint the areas between the trees where the tree trunks show through, working from top to bottom and using the flat brush. On the bottom part of the canvas, apply a glaze of Aquacryl paint in medium yellow to indicate a clearing. Let the canvas dry.

5. Now add a few accents in orange with Aquacryl paint in permanent yellow to indicate light reflections. Paint the shadows at the foot of the trees in diluted turquoise with an added drop of sepia airbrush paint. This will create a lovely shade of grey-blue.

◄ *Spring Mood in the Forest*, acrylic, 80 x 100cm (31½ x 39½in)

► Detail: The perspective makes the trunks at the front look darker than those in the background.

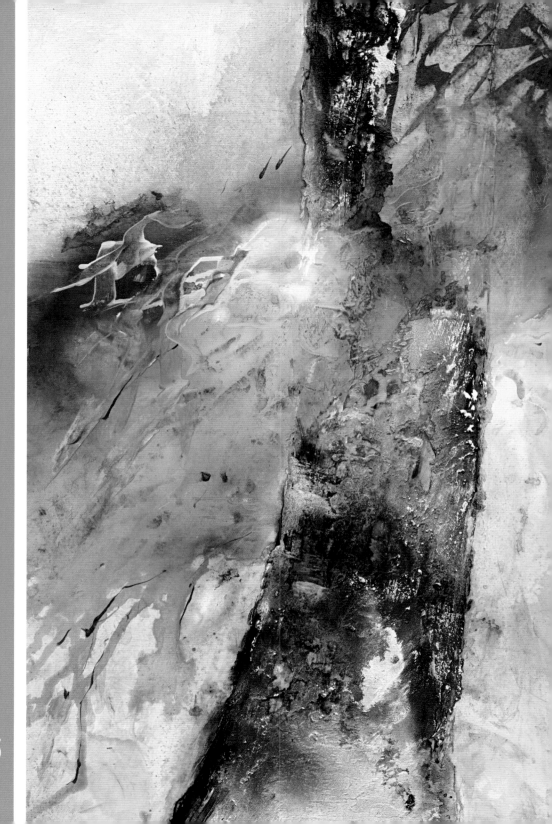

► *Spring Breeze in the Trees*, acrylic,
60 x 90 cm (23½ x 35½in)

Spring Breeze in the Trees

Materials

Rectangular canvas, e.g. 60 x 90cm (23½ x 35½in)
Acrylic paint in Indian yellow, lime green, turquoise, white, lemon yellow
Airbrush paint in olive brown, olive green, sepia
Fine paste
Flat brush, palette knife, rubber spatula
Spray bottle of water

▲ Detail: Let the paints flow into the trunk. This will create the impression of dense foliage.

▶ Detail, right: Scrape off paint you have already applied with the spatula to reinforce this effect and reveal individual leaves.

Step by step

1　Mix the paste with acrylic paint in white, and apply with the palette knife to shape the tree trunk. Prime the background in white.

2　Mix white with a little turquoise. Starting at the top and using the flat brush, paint the areas to the left and right of the trunk. Paint the lower half in lemon yellow. You can also extend these colours slightly into the trunk. Leave until completely dry.

3　Deepen the right side of the trunk in turquoise. Apply additional airbrush paint in sepia, and spray with water so that the paint flows into the tree trunk. Leave to dry.

4　Dilute lime green with water, and allow it to flow diagonally over the picture, starting at the corners. Leave it to stand for a short while.

5　Mix airbrush paint in olive brown and olive green, and again apply this blend diagonally, then spray everything with water. Angle the picture slightly to the right and left so the paints can flow together a little.

6　Leave the picture for a few minutes, then use the rubber spatula to scrape a little paint out again for the leaves. Leave until completely dry.

7　Dilute white with a little water, and allow the paint to flow over any areas that are too dark. Again, distort the white with the rubber spatula for the leaves. Add a few accents in Indian yellow and lemon yellow.

8　Take up some acrylic paint in white with the palette knife and apply to parts of the tree trunk.

Summer

The summer months are defined by strong colours, bright light and warmth. During this time, try to incorporate in your work the positive emotion that nature brings forth, with glowing reds, bright yellows and irresistible shades of blue and green.

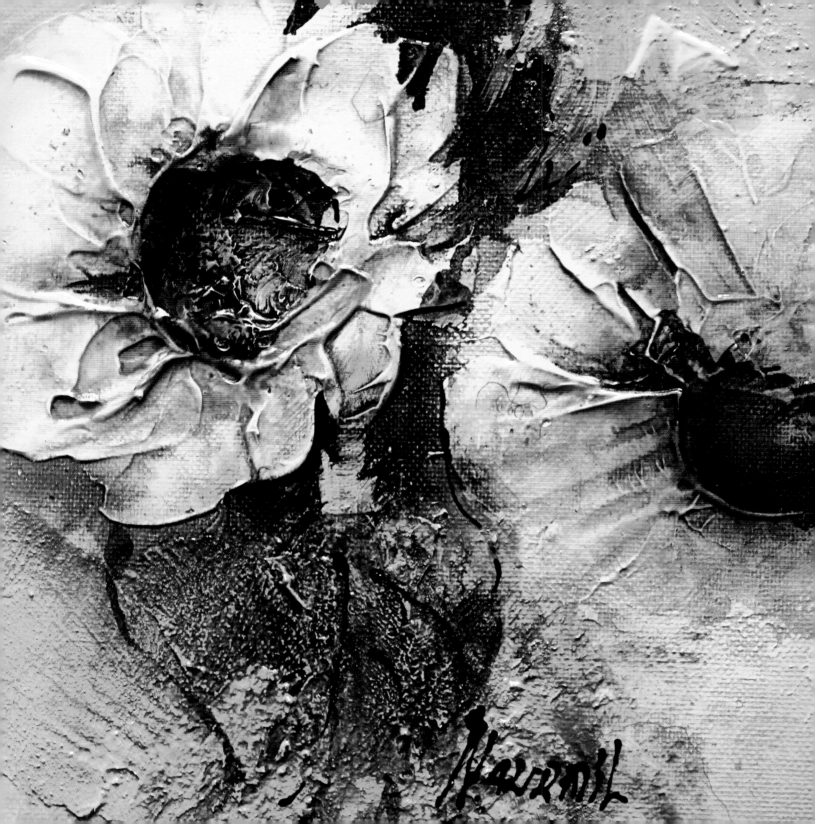

Flowering Suns

Materials

Square canvas, e.g. 20 x 20cm (7¾ x 7¾in)
Acrylic paint in oxide brown, lime green, white, lemon yellow
Heavy body acrylic paint in white
Aquacryl paint in medium yellow, permanent yellow
Airbrush paint in Brazil brown, olive green, olive brown
Sand
Flat brush, spatula
Spray bottle of water
Paper tissue or kitchen paper

Step by step

1 Prime the canvas in acrylic white paint and apply heavy body acrylic paint in white with the spatula for the sunflowers. To indicate the leaves, mix lime green with a little sand until you are happy with the consistency of the paste. Apply the mix with the spatula. Allow to dry.

2 Paint the sunflowers lightly and the background a little darker in the fresh shade of lemon yellow. Then use the flat brush to paint a glaze of Aquacryl paint in medium yellow over the flowers and background. Allow to dry a little.

3 Apply a glaze in oxide brown to the middle of the flowers, and add orange shadows to the petals with Aquacryl paint in permanent yellow. Allow to dry a little.

4 Apply the airbrush paint in Brazil brown to the middle of the flower, and spray with a little water. The brown paint will also flow into the indentations in the petals. Pat off any excess paint with a paper tissue or a small piece of kitchen paper.

5 Mix airbrush paints in olive brown and olive green, and allow them to flow over the sandy structure of the leaves. Outline the petals in the dark green you have just mixed with the airbrush paints.

6 Then apply lime green to the raised areas of the green surface to reflect the various greens of the leaves.

◀ *Flowering Suns*, acrylic, 20 x 20cm (7¾ x 7¾in)

▶ Detail: Outlining the petals in dark green adds dimensionality and shape to the sunflowers.

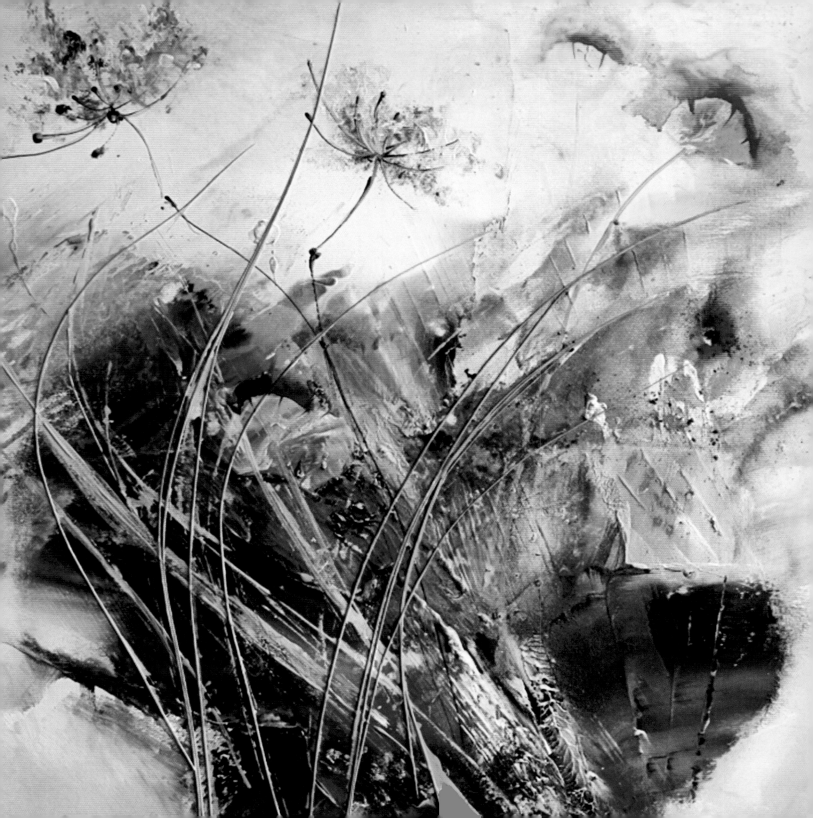

The Meadow

Materials

Square canvas, e.g. 80 x 80cm (31½ x 31½in)
Acrylic paint in Hooker's green, lime green, pigment yellow, turquoise, white, lemon yellow
Aquacryl paint in permanent yellow, permanent red
Airbrush paint in olive brown, olive green
Fine sand, fresh long grasses
Acrylic binder
Flat brush, angled brush, line brush, palette knife
Spray bottle of water
A piece of cardboard or paper

A tip from my art studio:

Creating textures

Long grasses and additional textures will add interest to your motif. The grasses cross the picture diagonally as thin lines here and there.

◀ *The Meadow*, acrylic, 80 x 80cm (31½ x 31½in)

▶ *Flower Meadow*, acrylic, 80 x 80cm (31½ x 31½in): I did not use fresh grasses for this picture; instead, I drew around them using a line brush and dark green airbrush paint.

Step by step

1 Prime the canvas in white and lemon yellow. Quickly blend a handful of sand with white and apply this mixture generously to the bottom one-third of the picture with a large palette knife. Quick movements of the palette knife will create different patterns. Leave until completely dry.

2 Shape the poppies with an angled brush using Aquacryl paint in permanent yellow. Spray on a little water, and drag the paint into the background.

3 When these areas are dry, shade the flowers in Aquacryl paint in permanent red. Intensify the background in white and lemon yellow. Darken the top left slightly in pigment yellow. Mix a little turquoise with white and apply to the bottom left and right to make the picture more lively and reflect summer's variety of colours.

4 Mix Hooker's green with airbrush colours olive green and olive brown. Dilute the paint with enough water so you can spread it over the sand in the spray bottle.

5 Put some lime green acrylic paint on a flat surface such as a piece of cardboard or paper, and drag long, fresh grasses through it. Leave to dry. Then apply acrylic binder generously to the grasses and those areas where you plan to put them. Stick the grasses to the canvas. While they are drying, press them onto the canvas until they stay put.

6 Paint the wild cumin into the grass in green and white with the line brush. Darken the grasses with lime green. You can also use lime green to lighten any areas that are too dark.

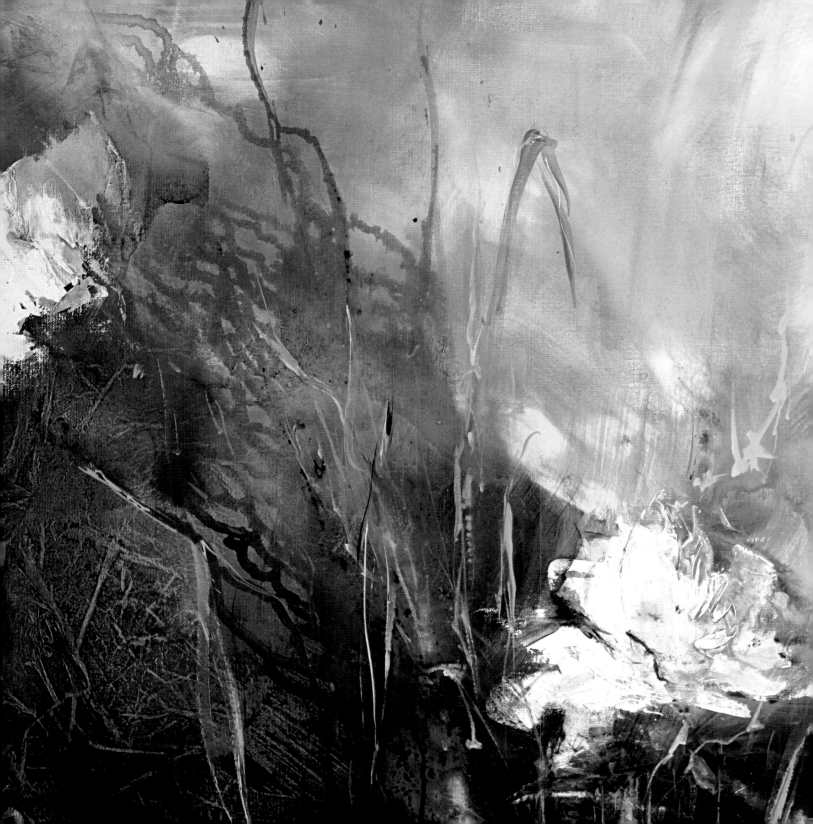

Lily Pond

Materials

Square canvas, 80 x 80cm (31½ x 31½in)
Acrylic paint in Hooker's green, Indian yellow, lime green, black, turquoise, white, lemon yellow
Heavy body acrylic paint in white
Aquacryl paint in medium yellow, permanent yellow
Airbrush paint in olive brown, olive green
Flat brush, angled brush, spatula
Spray bottle of water

A tip from my art room:

Creating contrasts

The white flowers are applied with a spatula, while the background is painted using the watercolour technique. The contrast between the paste colour application of the lilies and the delicate watercolour technique of the background adds variety and interest to the picture.

◀ *Lily Pond*, acrylic, 80 x 80cm (31½ x 31½in)

▶ *Lilies*, watercolour, 50 x 60cm (19¾ x 23½in): In order to achieve the typical transparency of a watercolour, the artist needs to paint with confidence and spontaneity.

Step by step

1 First shape the flowers in heavy body acrylic paint in white with a smaller spatula. Then prime the background with acrylic paint in white and lemon yellow with the flat brush. Allow to dry a little.

2 Paint over the background completely in lemon yellow, white and turquoise.

3 Mix Hooker's green with a little black, and apply this paint from the bottom to the first flower to set a focus.

4 Apply medium yellow Aquacryl paint to the middle of the picture and spray with water. Turn the picture slightly in all directions so the paint flows to the edges. This creates the impression of the sun reflected in the water.

5 When dry, glaze the motif as you see fit with a little Aquacryl paint in permanent yellow.

6 Mix airbrush paints in olive green and olive brown. Apply the paint along the bottom edge and spray this area with water. Now tilt the picture slightly from side to side to create elements that look like floating grasses. Use the angled brush with lime green to add some lively grasses.

7 Drag a little of the dark colour of the background into the flowers. The shadows will create the petals. Add a dot of lemon yellow with a little Indian yellow to the middle for the pistils.

8 Use turquoise and a little white to indicate the light reflections in the darker section of the picture.

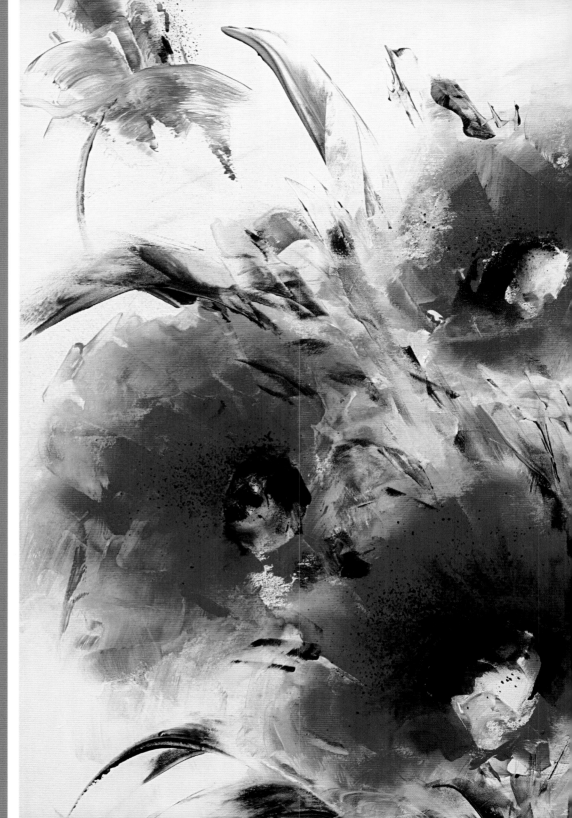

▶ *Large Poppies*, acrylic,
60 x 90 cm (23½ x 35½in)

Large Poppies

Materials

Rectangular canvas, 60 x 90cm (23½ x 35½in)
Acrylic paint in Hooker's green, cadmium orange, cadmium red, lime green, black, white, lemon yellow
Aquacryl paint in permanent red
Airbrush paints in olive brown, olive green, deep madder
Bristle brush, flat brush, palette knife, rubber spatula
Spray bottle of water

▶ Source photograph: Capturing the incomparable delicacy of the poppy requires practice. A rubber spatula is the perfect tool, since it enables you to create soft transitions and the impression of fine, layered petals.

Step by step

1 Apply the two flowers at the front generously with a narrow palette knife in cadmium orange, then apply a further one in cadmium red. Shape the black centres of the flowers with the flat brush.

2 Add a bud in cadmium red at the top left. When the flower is dry, paint over it lightly in white so it disappears slightly into the background. Now prime the uncovered canvas heavily in white. Blur the transitions to the flowers slightly with the flat brush. Leave to dry.

3 Shade the three large flowers with the flat brush, using airbrush paint in deep madder and Aquacryl paint in permanent red. Spray a little water onto the poppies so the acrylic paint is able to disperse.

4 Mix the airbrush paints olive brown and olive green, and add acrylic paint in Hooker's green. Apply this mix sweepingly to shape the leaves.

5 Take up some lemon yellow with a wide rubber spatula and drag the paint through the green leaves. The green will blend with the yellow, and lift off a little of the paint at the same time so that the white base is revealed. This makes the green look airy and transparent.

6 Where necessary, lighten any areas that are too dark with lime green. Leave to dry.

7 Finally, dilute a little black with water and spray onto the middle of the poppies using the bristle brush.

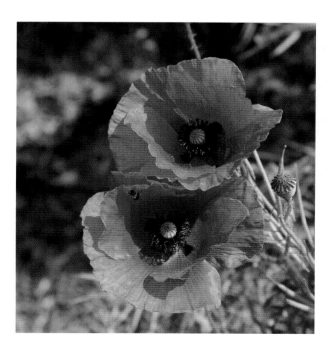

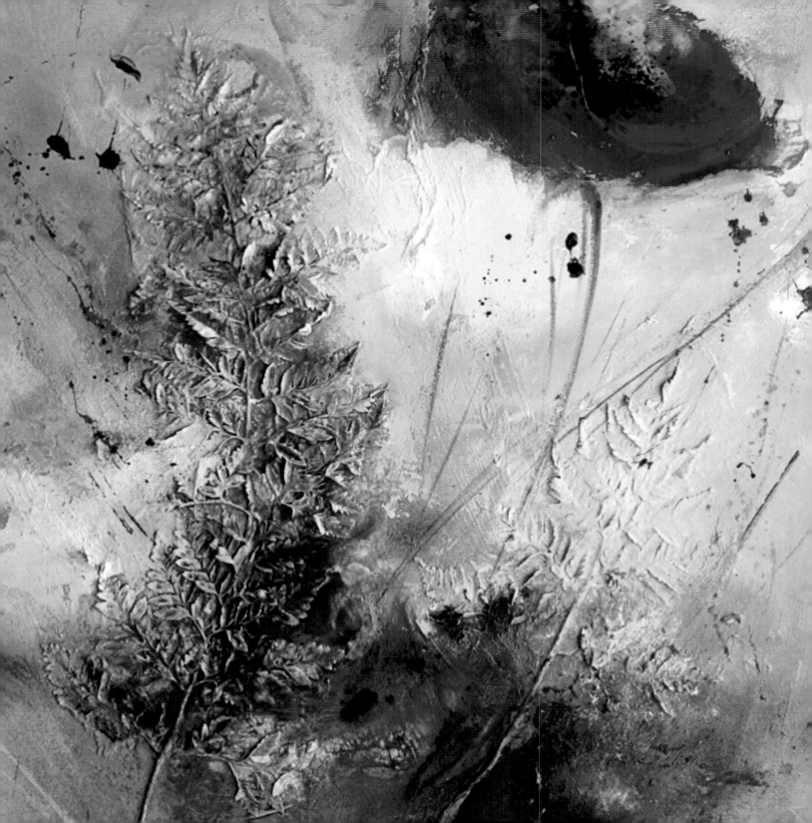

Poppy and Fern

Materials

Square canvas, e.g. 80 x 80cm (31½ x 31½in)
Acrylic paint in cadmium orange, lime green, black, white, lemon yellow
Aquacryl paint in permanent red
Airbrush paint in olive brown, olive green
Two fresh fern fronds
Acrylic binder
Bristle brush, flat brush, angled brush, spatula
Spray bottle of water

A tip from my art room:

Working with fresh fern

When painting this picture, it is important to use fresh ferns, as dried ferns will crumble when you stick them on. The acrylic binder and acrylic paint create an airtight seal that prevents the ferns from weathering. Do not use ferns with soft leaves, as they will not provide enough texture. Ferns from a florist are ideal.

◄ *Poppy and Fern*, 80 x 80cm (31½ x 31½in)

▶ Detail: The transition between the background and the flower blends smoothly.

Step by step

1 Use the flat brush to prime the canvas in white and lemon yellow. Then brush the ferns well with acrylic binder, and lay them on the canvas. Leave to dry for a short while, then brush acrylic binder over the ferns again, applying a little pressure. Leave until completely dry. You might have to press the ferns back down onto the picture from time to time.

2 Create the flower with cadmium orange and a small spatula. Brush the dried ferns well in white and lemon yellow. Nothing of the fern's natural colour should remain visible. Intensify the background with white, lemon yellow and lime green.

3 Mix airbrush paints in olive brown and olive green. Apply this mix to the ferns, then spray them with water. If you turn the picture, the paint should settle in the spaces between the ferns. This accentuates the structure of the ferns. Leave to dry.

4 Paint Aquacryl paint in permanent red onto the poppy and spray this area with water – a little of the paint will flow into the background, which will make the flower look even more delicate. Dilute black acrylic paint with water, and use a bristle brush to spray stamens into the middle of the poppies.

5 Once the picture is completely dry, lighten a few areas with white, lime green and lemon yellow. Use the angled brush to paint the stalks and a few grasses in sweeping strokes.

6 Dip the angled brush in a little green paint and hold it over the painting. Tap lightly on the brush handle so a few drops of paint splash onto the canvas.

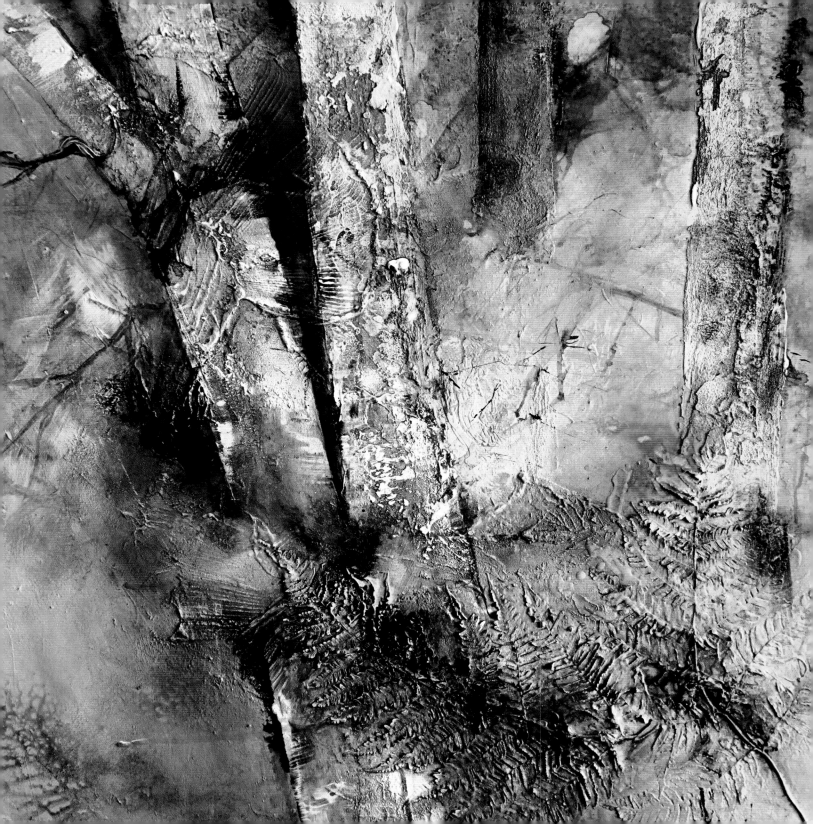

Sunny Forest with Fern

Materials

Square canvas, e.g. 80 x 80cm (31½ x 31½in)
Acrylic paint in Hooker's green, lime green, primary yellow, white, lemon yellow
Aquacryl paint in medium yellow, permanent yellow
Airbrush paint in olive brown, olive green
Sand, two fern fronds
Acrylic binder
Flat brush, angled brush, palette knife
Spray bottle of water

◄ *Sunny Forest with Fern*, acrylic, 80 x 80cm (31½ x 31½in)

▲ Detail: A few discreetly placed colour accents will add liveliness and excitement to the picture. Add a few branches to finish with.

1 Using the flat brush, prime the entire picture in lemon yellow acrylic paint. Brush the ferns well with acrylic binder, then leave to dry for a short while. Place the ferns on the picture, and paint generously with acrylic binder. While they are drying, keep pressing the ferns back down onto the canvas.

2 Paint over the entire picture again in lemon yellow; the ferns should also be lemon yellow. Cover a few areas in primary yellow.

3 Mix acrylic white with a little sand, and apply with a palette knife to create the tree trunks. You can also add a little of the paste to the background to liven it up.

4 Once it is dry, intensify the background again with acrylic paint in primary yellow to create a light-flooded scene.

Flow Aquacryl paint in medium yellow over the right side of the picture, including areas of the ferns and tree trunks.

5 Mix Hooker's green with airbrush paint in olive brown, and paint the green areas. Draw a little of the green paint into the tree trunks.

6 Mix airbrush paints in olive brown and olive green, and paint the darker areas. Spray with water, turn the picture a little, and let the water flow lightly over it.

7 Do the same with the ferns. The dribbled paint will highlight the individual ribs of the leaves.

8 Lighten some of the areas in lime green. Try to use as many different shades of green as possible to make the painting even livelier.

9 Spray the still-damp green areas with water to mix them together. You will be left with patches of colour in some areas that you will not be able to alter.

1 0 Emphasise some areas with Aquacryl paint in permanent yellow. Finally, add a few dark green branches with the angled brush.

▶ *Summer Tree*, acrylic,
60 x 90cm (23½ x 35½in)

Summer Tree

Materials

Rectangular canvas, e.g. 60 x 90cm (23½ x 35½in)
Acrylic paint in Hooker's green, Indian yellow, ochre, lemon yellow, lime green
Heavy body acrylic paint in white
Aquacryl paint in medium yellow, permanent yellow
Airbrush paint in olive brown, olive green, sepia
Flat brush, palette knife, rubber spatula
Spray bottle of water

▲ Detail:
The light colours to the left of the tree and the dark shadows on the right side create an exciting contrast between the sunny and shady sides of the tree.

Step by step

1 Use the flat brush to prime the canvas all over in lime green. Shape the tree trunk using heavy body acrylic paint in white and the palette knife.

2 When dry, paint parts of the tree trunk in ochre. Then intensify the background in lemon yellow. Apply the paint generously with a palette knife – do not worry about it being too thick – so that slight structures appear in places.

3 Mix Hooker's green with olive brown airbrush paint, then dilute this mixture thinly with water and allow it to flow over the right side next to the tree trunk. Allow to dry for a few moments.

4 Mix the airbrush paints olive brown and olive green. Apply the paint to the left next to the trunk and spray it with water. Turn the picture so that the paint runs all down the left side. It's fine if the paints also run over the trunk. Leave until completely dry.

5 Mix sepia airbrush paint with a little olive brown. Apply this paint to the tree trunk and spray with water. The paint will settle in the indentations, creating different shades of brown on the trunk.

6 Mix some more Hooker's green with olive brown airbrush paint, and paint dark shadows on the background. Remove some of the paint again using the rubber spatula to indicate leaves.

7 When dry, paint a few light areas in Indian yellow and lemon yellow. Dilute lemon and medium yellow Aquacryl paint with plenty of water, and allow to run over the painting at an angle by turning it a little.

8 When dry, allow a little Aquacryl paint in permanent yellow to flow onto the light yellow areas. Again leave until dry.

9 Apply a little airbrush paint in olive brown to the yellow areas, and spray with water. The paint should only run a little.

Autumn

Bright colours, exciting materials and a lovely, warm light typify this time of the year for the artist. A few final days full of light and sun still await you. At the same time, you will see plenty of signs on your walks that winter is approaching. Create one last memento that will bring you pleasure throughout the harsh days of winter.

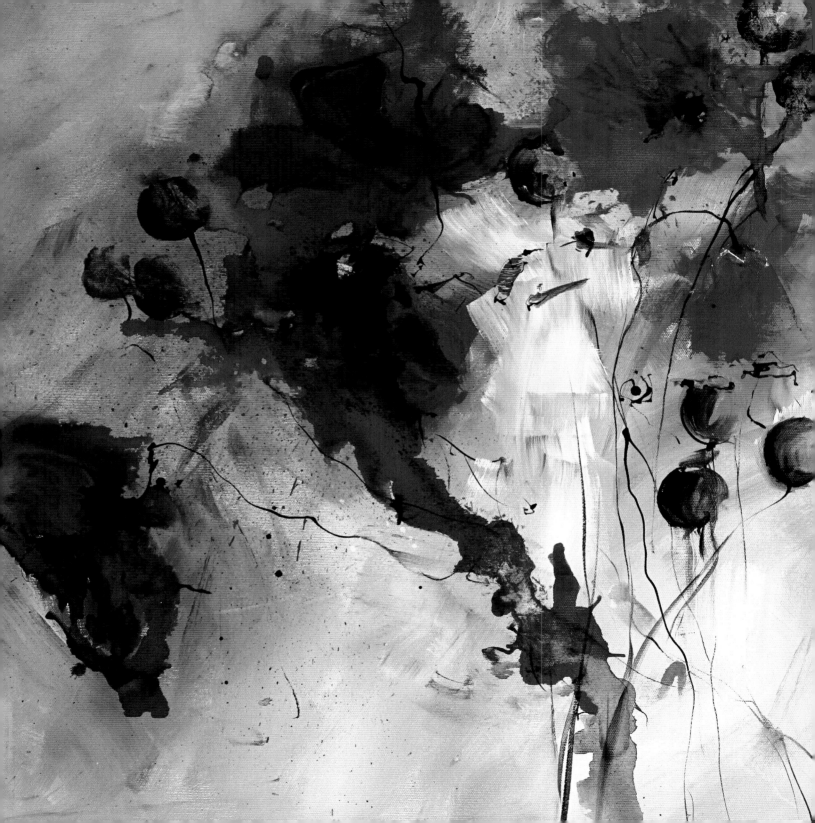

Autumn Poppy

Materials

Square canvas, e.g. 80 x 80cm (31½ x 31½in)
Acrylic paint in Indian yellow, cadmium orange, black, white
Aquacryl paint in permanent red
Airbrush paint in Brazil brown, deep madder, sepia
Flat brush, angled brush, line brush
Spray bottle of water

The idea behind the picture

Once when I was out walking on a late October day, I spied a few remaining poppies along the edge of a field. I collected some golden and brown leaves and grasses that I later tied into a charmingly playful bouquet. This colour combination inspired me to paint a number of poppy paintings with yellow and brown backgrounds. I have painted this motif mainly using the watercolour technique, which emphasises the delicacy of the poppies in a very pretty way.

◀ *Autumn Poppy*, acrylic, 80 x 80cm (31½ x 31½in)

▶ Another painting in this series: *Autumn Poppy*, mixed media, 50 x 60cm (19¾ x 23½in)

Step by step

1 Start by painting the poppies in cadmium orange using a flat brush, then immediately paint the background in white and Indian yellow using a wider flat brush. Indicate the seed pods in airbrush paint in Brazil brown. Leave everything to dry. Then shade the poppies with the angled brush using permanent red Aquacryl paint and airbrush paint in deep madder.

2 Dip a fingertip in black acrylic paint and dab a dot in the middle of some of the flowers. Now apply a second layer of white and Indian yellow paint to the background to further intensify the transparent effect.

3 When dry, again intensify the poppies with Aquacryl paint in permanent red. Spray water on the paint and allow it to float lightly into the background. You can control the flow of the red paint by turning the canvas in the desired direction.

4 Mix sepia and Brazil brown airbrush paint for a lovely, dark shade of brown.

Take up the angled brush and again intensify the seed pods. Using the same paint but this time the line brush, loosely paint some delicate stalks onto the picture.

5 When the painting is almost dry, shade the areas between the flowers with a flat brush and white acrylic paint to add some light reflections.

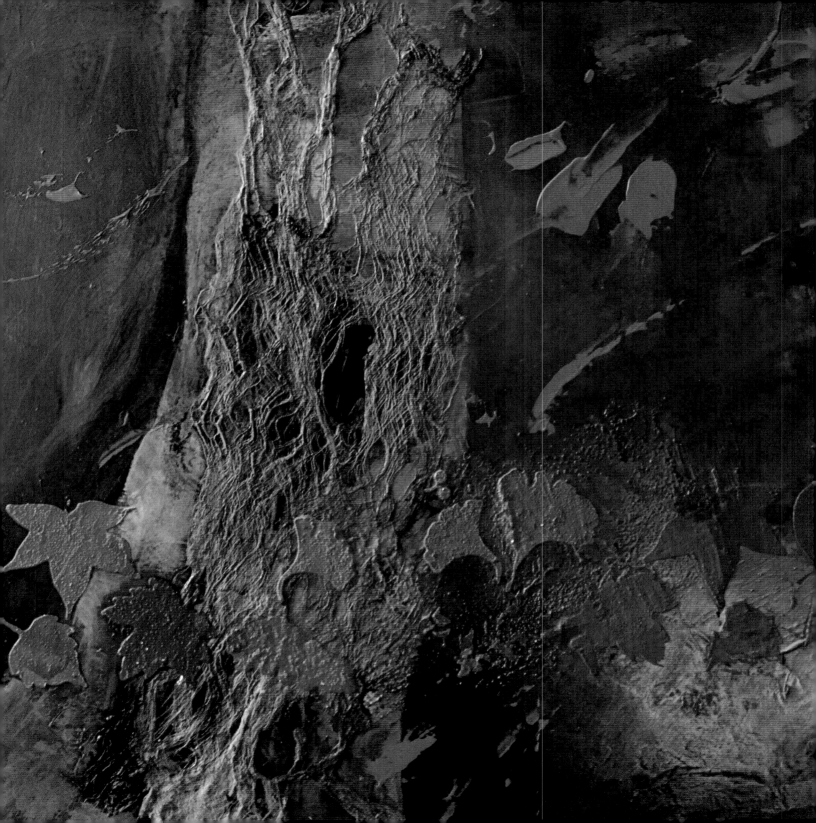

Abstract Autumn Tree

Materials

Rectangular canvas, e.g. 80 x 100cm (31½ x 39½in)
Acrylic paint in dark brown, cadmium orange,
dark madder, light ochre, Naples yellow, black, vermilion
Airbrush paint in deep madder
Fine sand, marble powder
Pressed bark, stencils of leaf motifs
Acrylic binder
Flat brush, angled brush, pencil, palette knife, spatula
Spray bottle of water
Adhesive tape, scissors, hot water

Step by step

1 Using a large flat brush, prime the canvas in acrylic paint in dark brown.

2 When dry, sketch the shape of the tree trunks in pencil. Then mix together fine sand, a little marble powder and acrylic paint in dark brown, and use a large palette knife to apply light structures to the left of the pencilled tree trunk. Leave to dry.

3 Use a large flat brush to paint the tree trunk in a mixture of cadmium orange, dark brown and a little black, and in light ochre.

4 Using the flat brush, apply more dark brown on the background to the left and right of the trunk. Allow to dry for a few moments. Then paint the areas to the left and right, but this time only at the bottom, in dark madder. Use the flat brush to create a soft transition to the dark brown paint. Leave until completely dry.

5 Dip the pressed bark in hot water for a moment, then squeeze it out well and pull it apart – this creates the fibrous areas. Place the bark on the trunk of the dry painting, and trim to shape with scissors.

◄ *Abstract Autumn Tree*, acrylic,
80 x 100cm (31½ x 39½in)

► Detail: The application of a paste makes the leaves look even more realistic.

Please turn over

6 Now brush the corresponding area of the trunk and the pressed bark generously with acrylic binder. Carefully place the bark on the canvas and shape it with your hands – keep pressing down on it while it is drying.

7 Glaze the background to the left and right of the trunk in dark madder, which will create a warm, slightly reddish shade of brown. Leave to dry.

8 Paint the area to the right of the trunk in vermilion. Leave until dry. Then apply cadmium orange on top. Glaze the bottom half lightly in cadmium orange.

9 When dry, lightly paint over the tree trunk with the flat brush and light ochre, but do not paint completely over the browns of the bark. Let a little watery ochre flow into the brown area to the left of the trunk.

1 0 Mix light ochre with Naples yellow, then dilute the resulting colour with water and paint the right side of the trunk so the various colours of the background still shimmer through.

1 1 Make a paste from the marble powder, a little fine sand and the acrylic paint in cadmium orange. Place a leaf stencil on the lower third of the picture. Secure on the left and right with adhesive tape and then, using a small spatula, carefully press the orange paste into one of the leaf stencils – the leaf must be completely covered. Continue like this until the stencil is filled.

1 2 Carefully remove the stencil. Wash it well before using it again so that it does not stick.

1 3 The leaves must be completely dry before you extend the row; otherwise you will smudge what you have painted so far.

When everything is dry, use an angled brush to shade the leaves with airbrush paint in deep madder. Use the spatula to indicate a few more leaves in cadmium orange, working from the top.

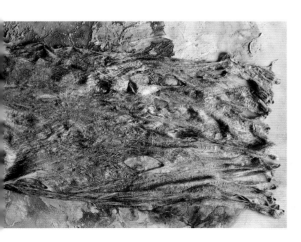

◄◄ Far left: Pressed bark before it is applied to the canvas.

◄ Left: Stencil with various leaf motifs.

A tip from my art studio: if a watercolour is too dark

The decision to work in mixed media can result from dissatisfaction with a picture. So what can you do if, for instance, a watercolour is too dark? I recommend using an opaque paint such as acrylic, Aquacryl or airbrush. You will see that these paints can usually be relied upon to make improvements.

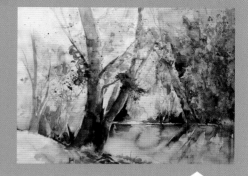

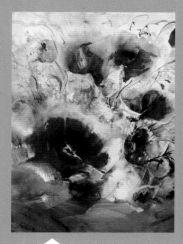

This landscape was lightened with Aquacryl paint in medium yellow. I then added a little airbrush paint in Brazil brown to Aquacryl in permanent yellow, and splashed it onto areas of the painting with a bristle brush.

Landscape, mixed media, 50 x 60cm (19¾ x 23½in)

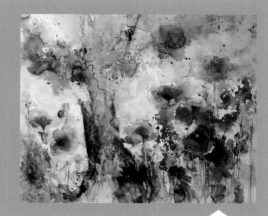

If the background is too dark, apply a thin glaze of acrylic paint to lighten it. I used blue and turquoise for this painting. Then I intensified the poppies with Aquacryl paint in permanent red.

Poppies, mixed media, 50 x 60cm (19¾ x 23½in)

I mixed airbrush paints in olive brown and olive green for this picture. I also intensified the poppies with Aquacryl paint in permanent red.

Poppies in Tuscany, mixed media, 50 x 60cm (19¾ x 23½in)

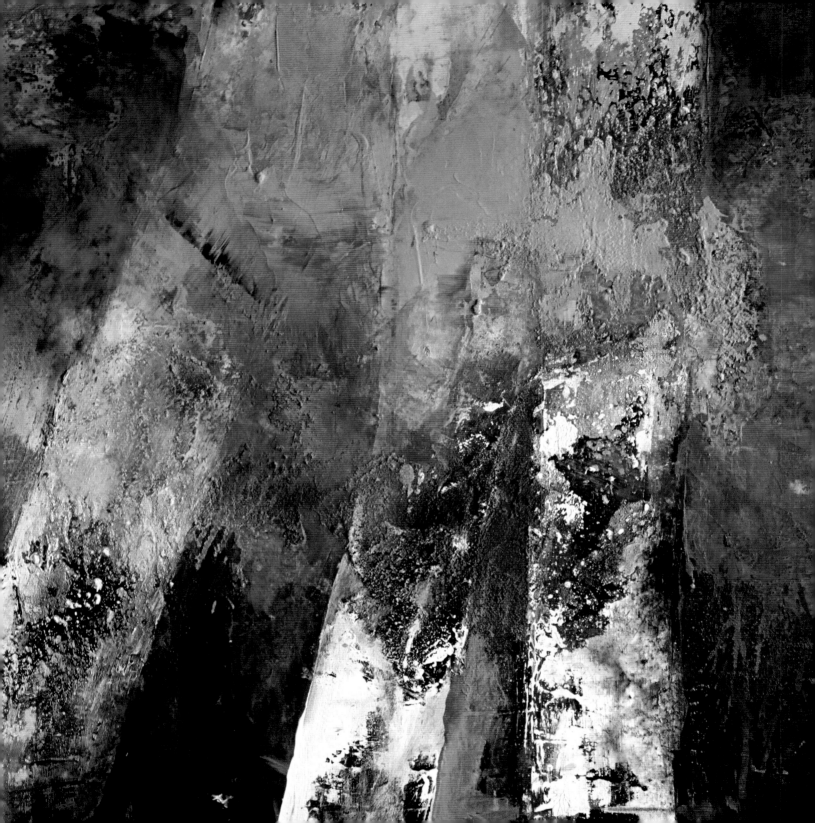

Fiery Autumn Forest

Materials

Square canvas, e.g. 80 x 80cm (31½ x 31½in)
Acrylic paint in Indian yellow, cadmium orange, deep madder, primary yellow, burnt umber, Vandyke brown, white
Aquacryl paint in permanent yellow
Airbrush paint in Brazil brown, sepia
Fine paste
Flat brush, palette knife, spatula
Spray bottle of water

◄ *Fiery Autumn Forest*, acrylic,
80 x 80cm (31½ x 31½in)

▶ *Sunny Birch Forest*, acrylic,
60 x 90cm (23½ x 35½in):
In this picture, the use of real leaves and a piece of pressed bark with longer fibres than in the picture on the left were used to add texture.

Step by step

1 Using the palette knife, apply burnt umber and Vandyke brown from the bottom up to the middle of the canvas. Apply primary yellow to the top part. Use the flat brush to create a harmonious transition.

2 When dry, glaze some parts of the dark areas in deep madder. Now shape the trunks using the spatula and fine paste. Leave to dry.

3 Let the airbrush colours sepia and Brazil brown flow into the trunks. Intensify the background with primary yellow and Indian yellow. Use these colours to join parts of the tree trunks. This creates a lovely autumnal atmosphere. Apply cadmium orange with the spatula.

4 Apply Aquacryl paint in permanent yellow generously on the left. Spray plenty of water onto the picture and turn it a few times so the paint flows across the picture. It will also blend with the other colours, resulting in different shades of orange.

5 When the picture is dry, moisten a few areas with airbrush paint in Brazil brown. Take up some white paint with the flat brush and run it lightly over the areas of the trunks that are too dark. Spray a little water onto areas of the white paint so that it flows into the background.

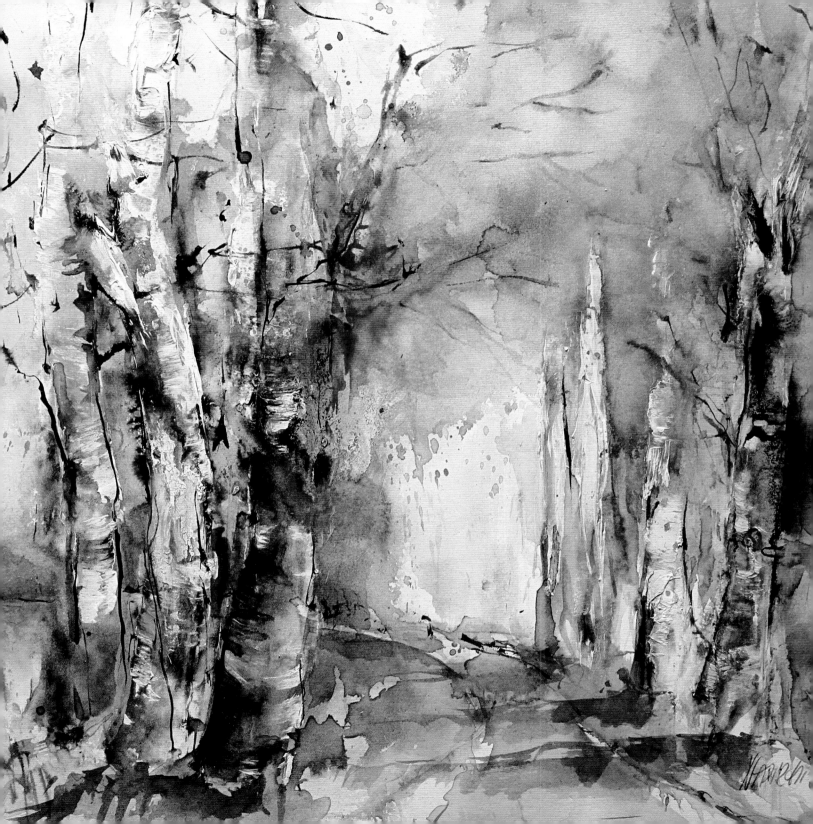

Autumn in the Birch Forest

Materials

Watercolour paper 640gsm (300lb) e.g. 50 x 60cm
(19³/₄ x 23¹/₂in)
Watercolour paint in mountain blue
Heavy body acrylic paint in white
Aquacryl paint in medium yellow, permanent yellow, black
Airbrush paint in Brazil brown
Flat brush, line brush, spatula
Spray bottle of water

Step by step

1 Start by pasting on heavy body acrylic paint in white in various thicknesses for the trunks. Make the trunks at the front a little thicker than those towards the back of the picture.

2 When dry, glaze the background with Aquacryl paint in medium yellow and a little watercolour paint in mountain blue to give the picture a warm, friendly atmosphere.

3 Then shade the trunks with airbrush paint in Brazil brown. Dilute Aquacryl paint in medium yellow with a little water and paint the background. Let the paint run over parts of the tree trunks. Leave uncovered the lighter areas of watercolour paint in mountain blue and Aquacryl paint in medium yellow. Indicate the path between the trees.

4 Indicate leaves here and there with Aquacryl paint in permanent yellow. Mix Brazil brown airbrush paint with black Aquacryl paint to make a dark shade of brown, and use the line brush to indicate branches in the picture before it dries. Use it to highlight the trees a little as well.

5 Dilute airbrush paint in Brazil brown with water, and use a thin, flat brush to form the shadows of the trees on the path.

◄ *Autumn in the Birch Forest*, mixed media,
50 x 60cm (19³/₄ x 23¹/₂in)

► Detail: The shadows add a three-dimensionality to the picture as well as providing an exciting contrast to the dominating, friendly shades of yellow. The result is a peaceful autumn scene.

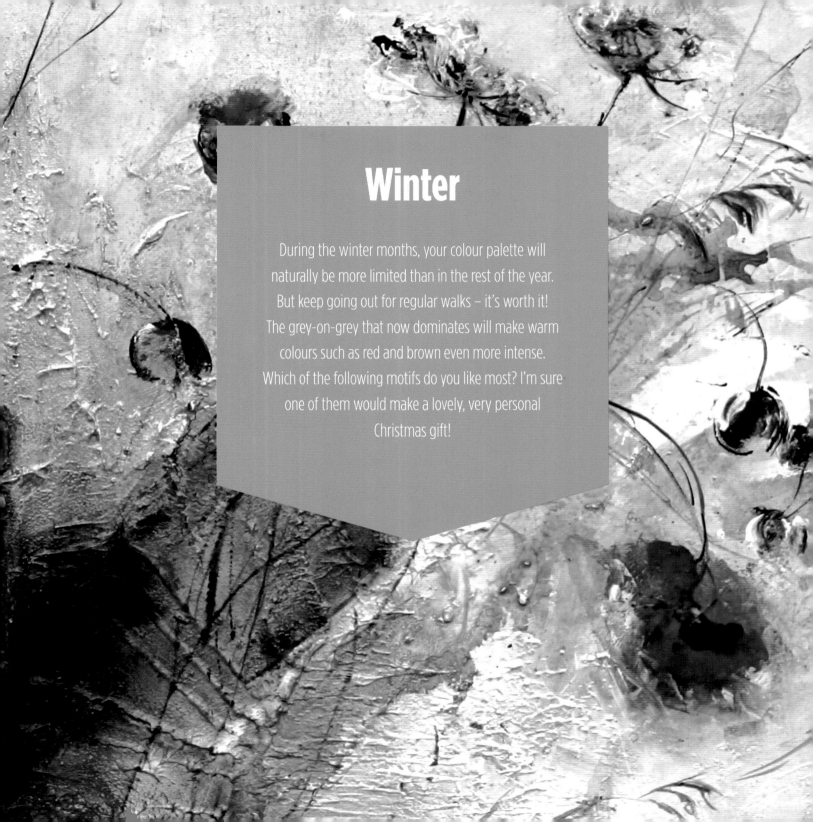

Winter

During the winter months, your colour palette will
naturally be more limited than in the rest of the year.
But keep going out for regular walks – it's worth it!
The grey-on-grey that now dominates will make warm
colours such as red and brown even more intense.
Which of the following motifs do you like most? I'm sure
one of them would make a lovely, very personal
Christmas gift!

▶ *Abstract Poppy 2*, lettering in ochre, acrylic, 50 x 60cm (19¾ x 23½in)

▶▶ *Abstract Poppy 1*, lettering in red, acrylic, 50 x 60cm (19¾ x 23½in)

Abstract Poppy

Materials

Two rectangular canvases, e.g. each 50 x 60cm (19¾ x 23½in)
Acrylic paint in cadmium orange, dark madder, ochre, black, burnt umber, Vandyke brown, white, vermilion
Aquacryl paint in permanent red
Airbrush paint in deep madder
Fine sand, marble powder
Acrylic binder
Letter stencil, adhesive tape (optional)
Flat brush, angled brush, palette knife, spatula
Spray bottle of water, plastic bottle with measuring tip
Plastic bowl

Step by step

1 Use a palette knife to apply large areas of acrylic paint in ochre, black, burnt umber and Vandyke brown to the two canvases. Put more of the darker colours on the bottom halves of the pictures to set the focus there. Paint the pictures in parallel to create a two-piece painting in beautiful, matching colours.

2 When dry, glaze the dark browns lightly in dark madder using the flat brush. As you apply it, be sure to make a harmonious transition of colour from one canvas to the other. Paint a few little areas in vermilion.

3 Mix a paste from the acrylic binder, marble powder and fine sand, and apply it to the middle of the two pictures only, with the palette knife.

4 When dry, intensify any parts of the background that seem to need it. Dilute white acrylic paint with plenty of water in a plastic bowl, and pour it evenly over the first canvas. Spray it lightly with water, then turn the picture so the paint can flow in various directions. Repeat with the second canvas. These techniques can and should allow the white to mix with the browns in some parts of the paintings.

5 When dry, use the spatula with cadmium orange to shape the poppies. Then paint the centres in black, and leave to dry.

6 Take up the angled brush and glaze the flowers with permanent red. Allow to dry for a few moments. Then add some deep shadows with airbrush paint in deep madder to make the picture more structured. Dilute vermilion in a small plastic bottle and draw some lively lines across the two pictures.

7 When dry, mix the ochre with a little sand. Place a letter stencil on the first picture and secure with adhesive tape if necessary. Use the spatula to carefully press the paste into the letters of your choice. Carefully remove the stencil, taking care not to smudge the letters. Repeat on the second picture, but this time mix vermilion and marble powder to create the letters.

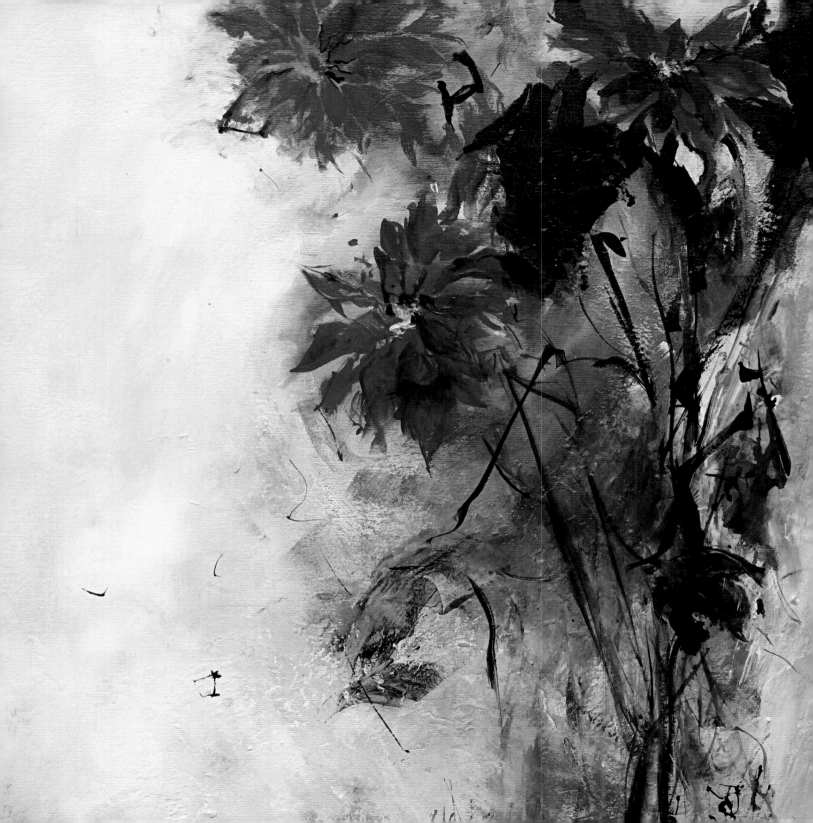

Poinsettias

Materials

Square canvas, e.g. 80 x 80cm (31½ x 31½in)
Acrylic paint in Hooker's green, Indian yellow, cadmium orange, cadmium scarlet, dark madder, olive green, black, turquoise, white, lemon yellow
Aquacryl paint in permanent red
Airbrush paint in deep madder, olive brown, olive green
Flat brush, angled brush, spatula
Spray bottle of water

◄ *Poinsettias*, acrylic, 80 x 80cm (31½ x 31½in)

► *Poinsettias – Variation*, acrylic, 10 x 15cm (4 x 6in): This picture was painted on watercolour paper using the technique described on page 19. This produces a lovely light result.

Step by step

1 Use a small spatula to form two star-shaped flowers in cadmium orange, and the third flower and more subtle flowers at the very bottom in cadmium scarlet. Using the flat brush, prime the background generously in white. Leave to dry. Mix white, black and a little turquoise for a blue-grey. Then apply another layer of white mixed with a little blue-grey all over the picture.

2 Shade the flowers deeply using the angled brush with Aquacryl paint in permanent red and airbrush paint in deep madder.

Paint lemon yellow beneath the flowers. Now shape the dark red flowers in dark madder using quick strokes.

3 Glaze the background again with the flat brush and a layer of acrylic paint in white, and apply a glaze of Indian yellow to the area beneath the flowers. Let this area dry a little, then glaze in cadmium orange. This will allow the other shades of yellow to shine through slightly.

4 Paint the lighter leaves in olive green. Mix Hooker's green with airbrush paint in olive brown, and add darker leaves and stalks to the picture using the angled brush. Apply a few fine brushstrokes to the motif to enliven it.

5 Apply a little airbrush paint in olive green below the flowers and spray with water. Add a few dots of turquoise.

6 Paint a white glaze over the background.

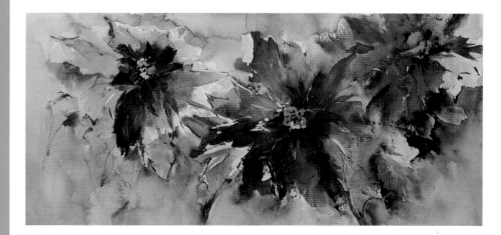

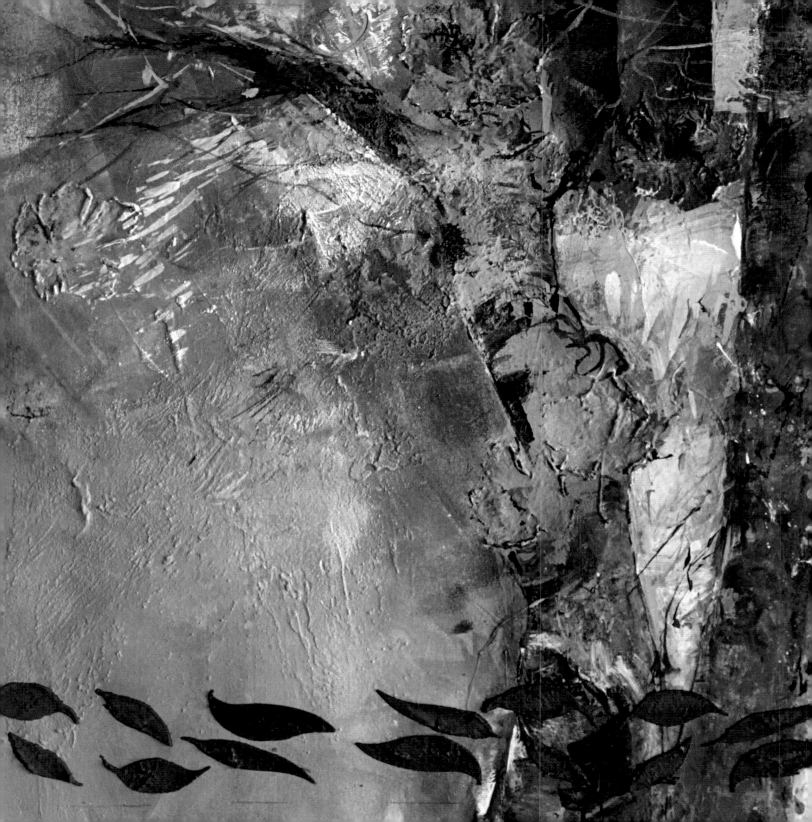

Winter Abstract

Materials

Square canvas, e.g. 70 x 70cm (27½ x 27½in)
Acrylic paint in dark madder, ochre, permanent red, black, turquoise, white
Airbrush paint in deep madder
Marble powder
Sand
Leaves
Leaf stencil, adhesive tape (optional)
Flat brush, line brush, rubber spatula

◀ *Winter Abstract*, acrylic, 70 x 70cm (27½ x 27½in)

▶ Photo: I wanted to capture a calm, wintry mood with my picture. At first sight, the colours look quite pared down, but when you look again, you'll notice spots of colour flashing through, such as the green branches of the pine trees or of any leaves that have not yet rotted.

Step by step

1 Using the flat brush, prime the canvas in black. Mix black and white to make various shades of grey and glaze the picture.

2 When dry, add the tree trunks with the line brush in black paint. Brush the grey mix you made earlier over a few of the leaves and glue them to the picture. Leave to dry.

3 Mix the sand with the grey acrylic paint mix. Apply to shape the tree trunks, and to enhance the background as appropriate.

4 Now glaze the picture again in various shades of grey. When dry, paint dark areas onto the trunks. Then use the spatula to indicate snow in the picture.

5 Add a few ochre and permanent red accents to the leaves. Indicate the remnants of green leaves in turquoise, adding a decorative highlight at the same time. Thicken dark madder with marble powder. Place the leaf stencil on the bottom edge of the picture. Secure with adhesive tape if necessary, and work the thick acrylic paint into the indentations with the spatula. Carefully remove the stencil. Leave it to dry completely. Only then should you continue the row of leaves.

6 Finally, shade the stencilled leaves with airbrush paint in deep madder.

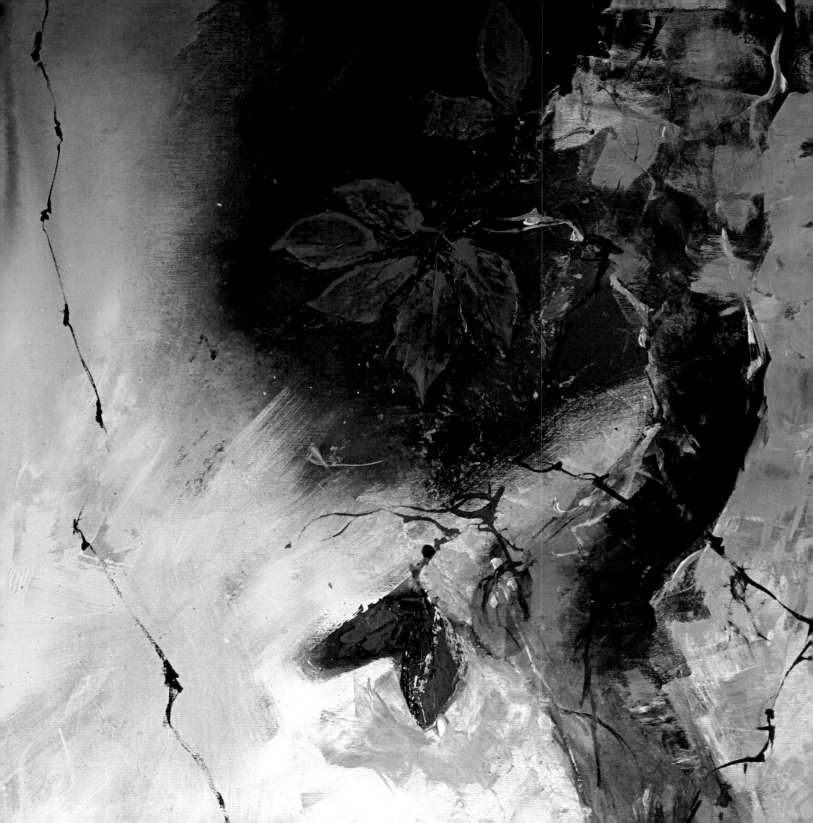

Virginia Creeper in Winter

Materials

Square canvas, e.g. 70 x 70cm (27½ x 27½in)
Acrylic paint in cadmium orange, ochre, black, white
Aquacryl paint in permanent red
Airbrush paint in deep madder
Leaves from a Virginia creeper or similar
Flat brush, angled brush, line brush, rubber spatula

A tip from my art room:

Fresh leaves in winter?

Usually the last days of autumn or early days of winter make me want to use muted colours as it can be difficult to find rich, green leaves. Yet you may also find a few weeds that you can trim to the desired shape. A vine in winter – dull hues enlivened by a few spots of colour – is both warm and mysterious.

◄ *Virginia Creeper in Winter*, acrylic,
70 x 70cm (27½ x 27½in)

► Detail: The red of the vine leaves glows against the black background.

Step by step

1. Paint the outlines of the vine with the line brush and black acrylic paint. Then paint it in a grey mix and black acrylic paint with the flat brush. Paint the background in black.

2. Brush cadmium orange generously over the backs of the leaves and apply them to the canvas. Keep pressing down on the leaves while the picture is drying so they do not come off again later.

3. Paint the fronts of the leaves in cadmium orange. Again, leave until completely dry.

4. Lighten the background with white, but leave the areas around the leaves black. It's better to paint the left side of the picture with a wide flat brush, as the transition from white to black should not be too harsh. Work the right side of the picture with the rubber spatula.

5. Shade the leaves with the angled brush using Aquacryl paint in permanent red and airbrush paint in deep madder. Take up a little ochre on the rubber spatula and brush lightly over a few parts of the trunk.

6. To finish, use the line brush and airbrush paint in deep madder to indicate a few branches in the picture.

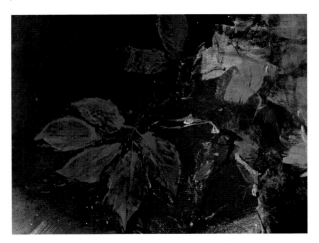

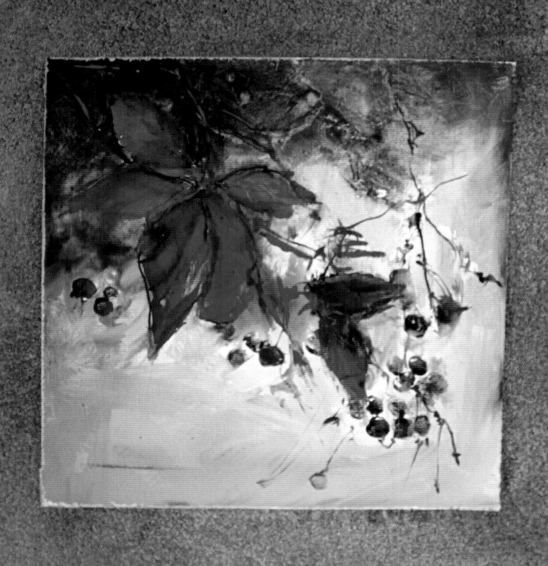

Virginia Creeper in a Grey Frame

Materials

Square canvas, e.g. 70 x 70cm (27½ x 27½in)
Acrylic paint in cadmium orange, permanent red, black, white
Aquacryl paint in permanent red
Airbrush paint in deep madder, olive brown, ultramarine
Leaves from a Virginia creeper, sand
Flat brush, angled brush, pencil, line brush, roller
Plastic bottle with measuring tip
Flat container, e.g. paper plate
Masking tape

The idea behind the picture

Originally, I only wanted to experiment with the principle of 'wide frame, small picture'. But I liked the idea so much that the experiment led to a new series. You will find several variations in colour and motif here and on the next two pages.

◄ *Virginia Creeper in a Grey Frame*, acrylic, 70 x 70cm (27½ x 27½in)

► *Virginia Creeper – Variation 1*, acrylic, 70 x 70cm (27½ x 27½in)

Step by step

1 Use a pencil to draw a line about 15cm (6in) from each of the edges. This is intended as rough guidance only. You can choose a different size – you will have to measure the edges again more precisely at the end.

2 Prime the resultant square in white. This is where you will paint the motif.

3 Brush cadmium orange over the backs of the leaves and press them firmly onto the canvas. When dry, brush the fronts of the leaves with the paint as well.

4 Combine white and black to make a light grey, and paint the white background with the flat brush. For the darker area at the top left of the picture, add black to airbrush paint in olive brown. This results in a dark grey with a touch of green. Use the flat brush to create a soft transition between the greys.

5 Shade the orange leaves with Aquacryl paint in permanent red, and allow a little airbrush paint in deep madder to flow deeply into some areas.

6 Mix together Aquacryl paint in permanent red and airbrush paint in deep madder. Dip a fingertip into the paint and dot red berries onto the picture. Then, in the same colour and using the line brush, add some delicate stalks and twigs. Add a little airbrush paint in ultramarine to some of the berries.

7 When the picture is completely dry, add the frame, which must measure exactly 15cm (6in) this time. Stick the masking tape to the pencil lines. Press down well so the paint does not seep through when you use the roller.

Please turn over

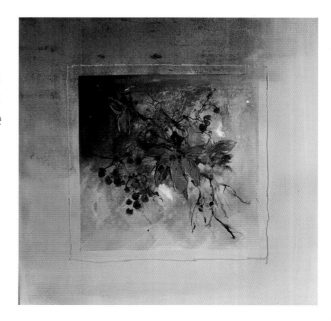

8 Put some acrylic paint in white in a flat container and run the roller through the paint. The roller should be completely covered. Roll the edge of the picture evenly, using plenty of paint. Then sprinkle sand over the wide edge. Do not press down – the sand should measure a few centimetres deep, then it will work its way into the

acrylic paint by itself. Allow to dry for a few moments, then place the picture upright so the excess sand can slide off.

9 Carefully remove the masking tape while the paint is still slightly wet, or it will be difficult to remove. Leave until the picture is completely dry.

10 Finally, pour permanent red acrylic paint into a plastic bottle. Dilute with

a little water, then draw lines along the sides of the picture, about 5cm (2in) from each edge of the canvas.

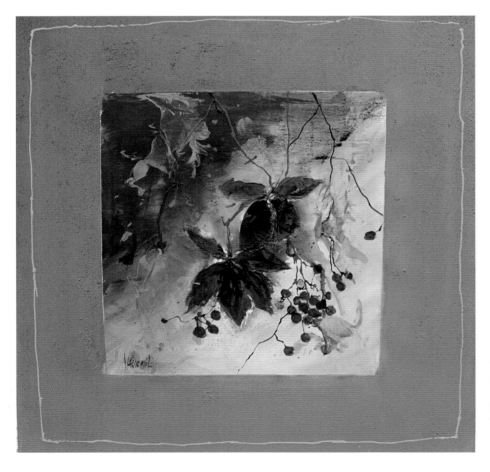

◄ *Virginia Creeper – Variation 3*, acrylic, 70 x 70cm (27½ x 27½in)

▶ *Rose Hips – Variation 2*, acrylic, 70 x 70cm (27½ x 27½in)

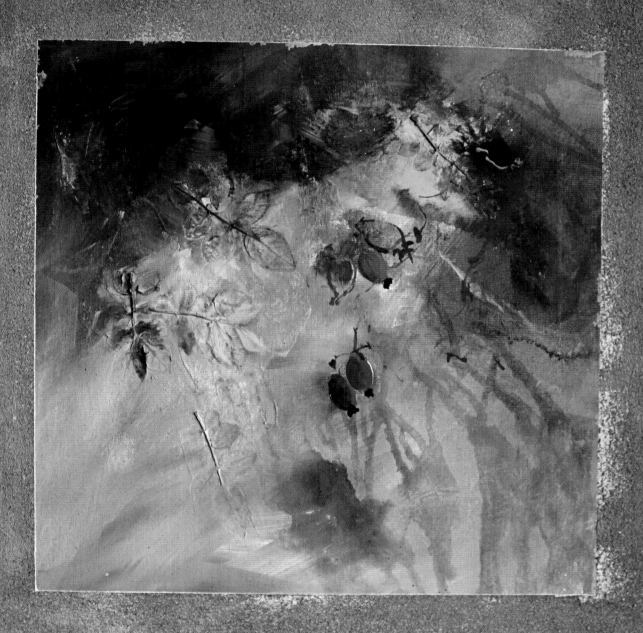

Gallery and closing words

In this, the final chapter, I would like to add a few motifs from my own work to those in the practical section.

If you do not think you are quite ready to create your own compositions, I would like to give you some suggestions in this gallery for how you can incorporate different flowers and trees into your own works of art.

Do not worry about copying the motifs exactly – you are under no pressure to show your pictures to the public as soon as you finish them. This book is meant to be read, and to be a source of inspiration with ideas and exercises. I would be delighted if it were to kindle or deepen your desire to create something of your own, so feel free to change the compositions and to add new colours. Add an extra flower to your picture, or perhaps remove a tree trunk from it. Make the background yellow instead of blue – the result will be an entirely new picture, and one that is your very own.

Dandelion, acrylic, 80 x 80cm
(31½ x 31½in)

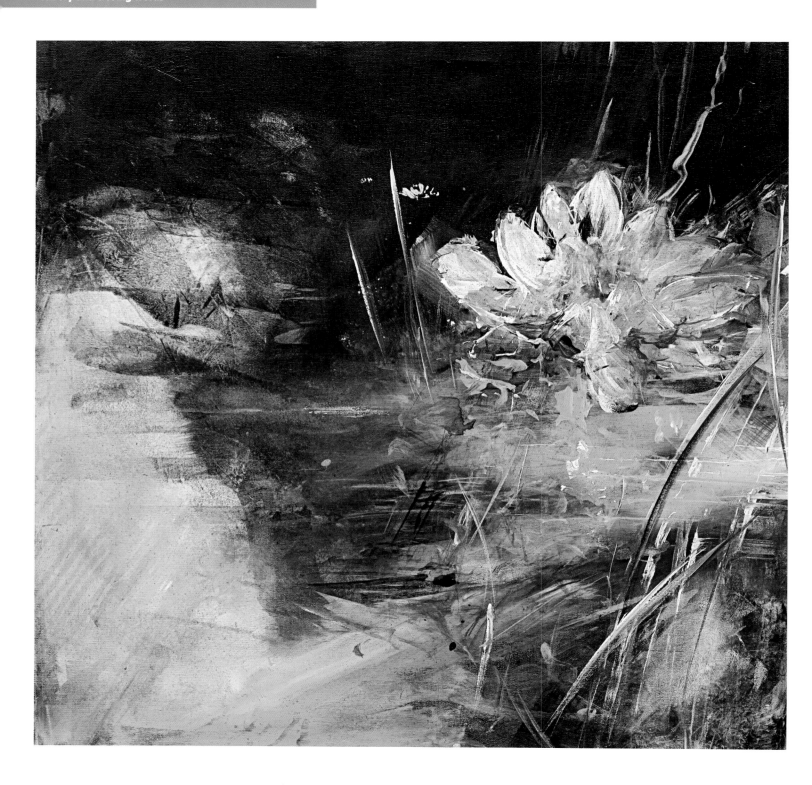

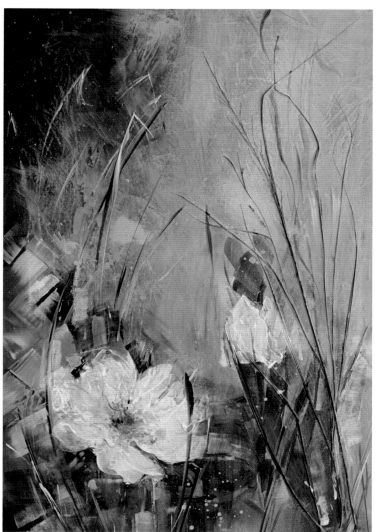

Lily variations

Variations between the shapes, rather than in the colours of the flowers, were the focus of this series.

I found it helpful to make series of my own motifs, or to paint one motif in several different variations. You will be amazed at how the ideas will simply start to flow once you work really intensively with a subject.

Left: *Lily – Variation 1*, acrylic, 70 x 70cm (27½ x 27½in)
Top left: *Lily – Variation 2*, acrylic, 80 x 80cm (31½ x 31½in)
Top right: *Lily – Variation 4*, acrylic, 60 x 90cm (23½ x 35½in)

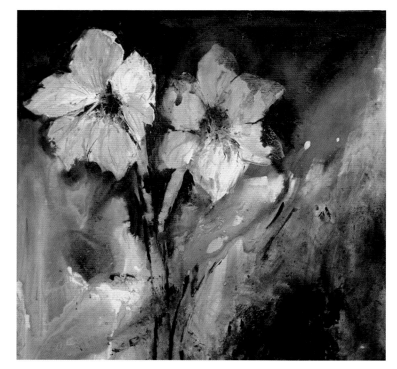

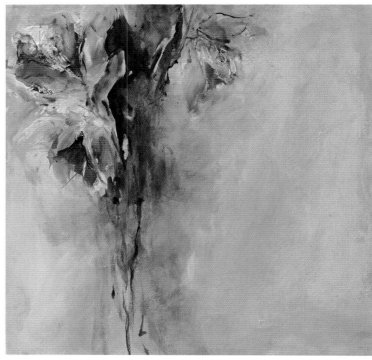

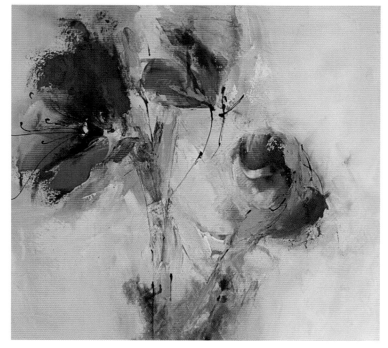

▼ Amaryllis

I painted this picture using the watercolour technique. The dark background really shows the pink-and-white flowers at their best.

Amaryllis, acrylic, 70 x 70cm (27½ x 27½in)

◄ Amaryllis

These large flowers are enhanced by a calm, bright background that does not draw attention from the main theme. I mixed acrylic paint in permanent red with sand and applied it with a palette knife to make the flowers look structured.

Amaryllis, acrylic, 80 x 80cm (31½ x 31½in)

▲ Pink Flowers

Asymmetrically arranged motifs increase the tension in the picture. The flowers are made using sand and a spatula. The light grey background emphasises the delicacy of these flowers.

Pink Flowers, acrylic, 80 x 80cm (31½ x 31½in)

► Poppy Meadow

In an almost endless variety of colours and sizes, poppies delight the wanderer.

Poppy Meadow – Variation 5, acrylic, 80 x 80cm (31½ x 31½in)

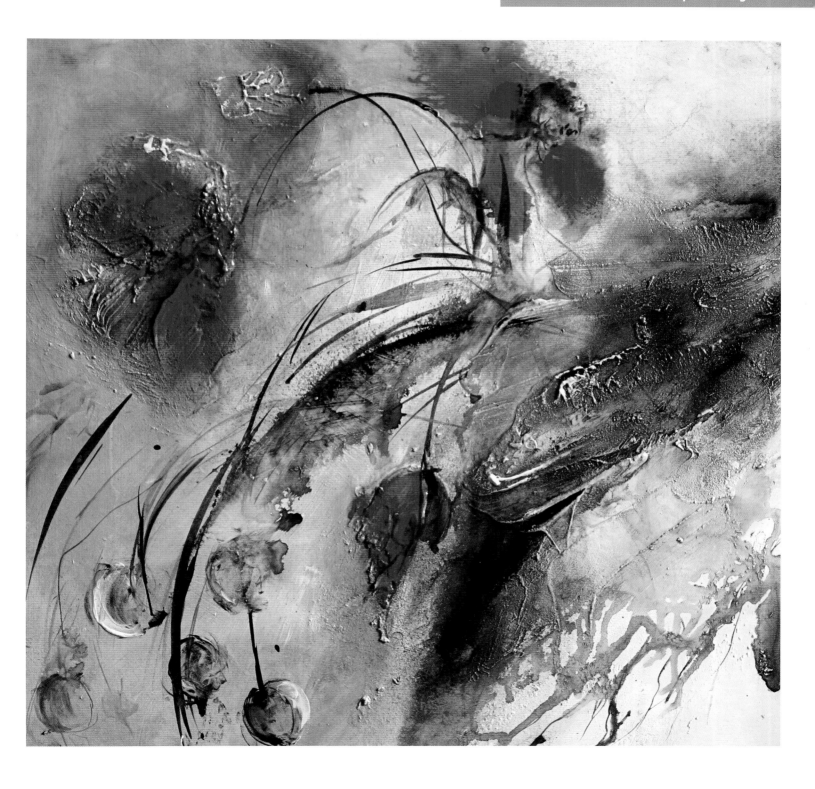

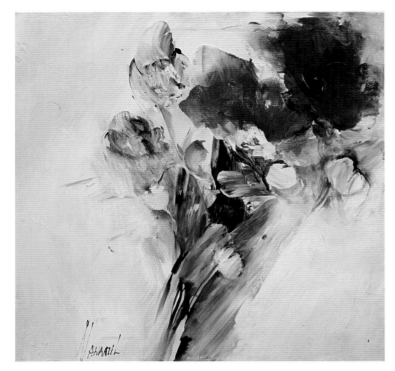

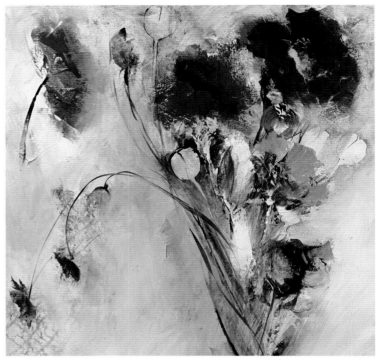

Poppy Meeting

Poppies are my favourite subject. I constantly find myself inspired to paint them in new variations. No other motif makes me as keen to capture the variety of summer's colours.

Top left: *Poppy Meeting – Variation 1*, acrylic, 60 x 60cm (23½ x 23½in)
Top right: *Poppy Meeting – Variation 3*, acrylic, 60 x 60cm (23½ x 23½in)
Bottom: *Poppy Meeting – Variation 4*, acrylic, 60 x 60cm (23½ x 23½in)

► Vine

A blue vine: the starting point for the much-loved wines of Tuscany.

Vine – Variation 2, acrylic, 80 x 80cm (31½ x 31½in)

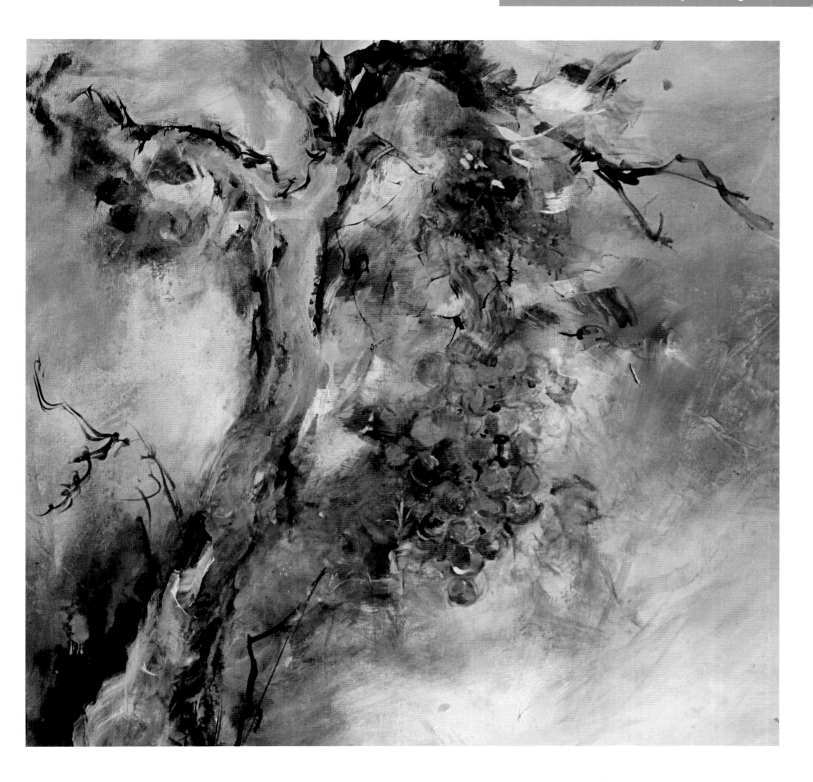

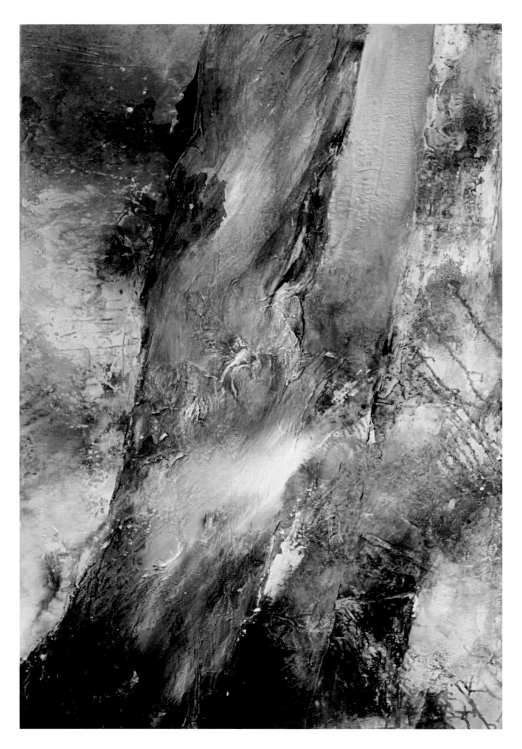

◄ **The Magic of Trees**

This tree motif turned out to be an unexpected challenge. On the one hand, I had to control an exceptionally large canvas, and on the other to shape the pressed bark into a massive tree trunk, which I then painted over almost completely. I worked the second trunk more delicately with paste.

The Magic of Trees, acrylic, 90 x 150cm (35½ x 59in)

▶ **Colour Play in the Forest**

Here I painted over a poppy picture that had been unsuccessful. However, I retained the structure and colours of the flowers.

Colour Play in the Forest, acrylic, 80 x 80cm (31½ x 31½in)

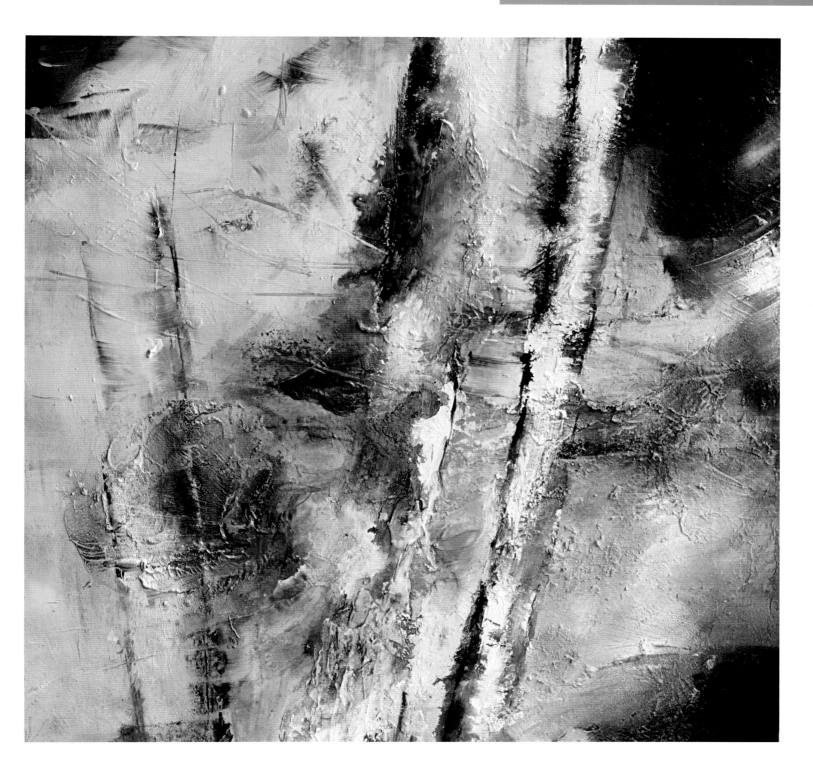

About the author

Born in 1947 and raised in pretty Styria, Austria, Waltraud Nawratil lives with her family in Schönering. Her home contains the little art studio in which she has worked as a freelance artist since 1995.

Waltraud Nawratil offers art courses in which she combines the technique of watercolour painting with acrylic paints. It is important to her that she encourages her students to vary her motifs and work, step by step, to develop their own style.

Waltraud's own artistic development began with watercolour painting. Due to the particular intensity of the colours in this technique, she mainly painted flowers to begin with. However, other subjects soon followed – motifs that she found on her many walks. She also enjoyed experimenting with different painting techniques and media. The pictures that you see below give you an insight into her work. You can purchase some of Waltraud Nawratil's works on the artists' platform, International Graphics.

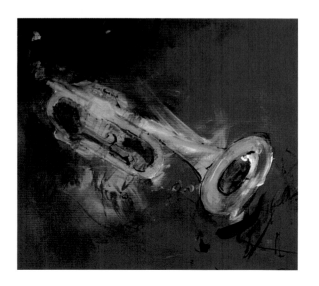

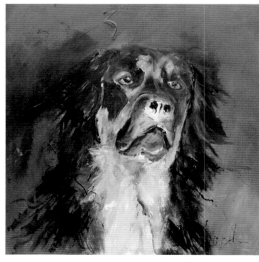

◄◄ *Trumpet*, acrylic, 80 x 80cm
(31½ x 31½in)

◄ *Duke*, acrylic, 80 x 80cm
(31½ x 31½in)

First published in Great Britain 2016
by Search Press Limited
Wellwood, North Farm Road,
Tunbridge Wells, Kent TN2 3DR

© Edition Michael Fischer GmbH, 2013

This translation of **DIE STRUKTUR DER NATUR** first published in Germany by Edition Michael Fischer GmbH in 2013
is published by arrangement with Silke Bruenink Agency, Munich, Germany

English Translation by Burravoe Translation Services

Layout: Tim Anadere, Claudia Weyh
Photographs: boesner GmbH (page 10, bottom centre; page 14), Edition Michael Fischer (page 10, top),
Waltraud Nawratil (all other photographs)

ISBN 978-1-78221-238-6

If you have difficulty in obtaining any of the materials and equipment mentioned in this book, then please visit the
Search Press website for details of suppliers: www.searchpress.com

Printed in China

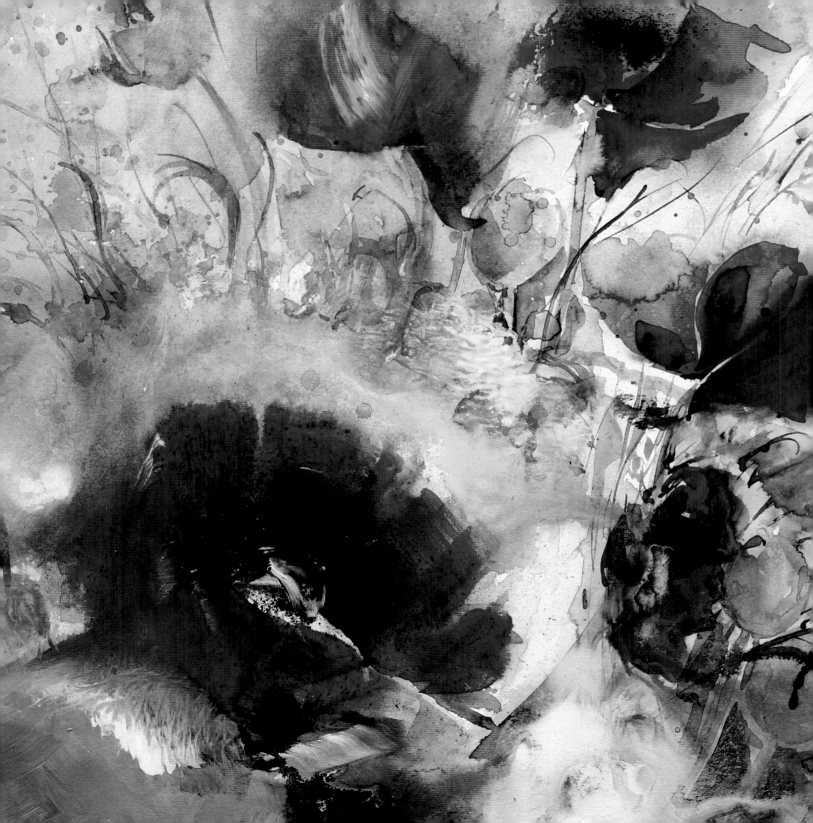